Steina

and

Woody

Vasulka

MACHINE

MEDIA

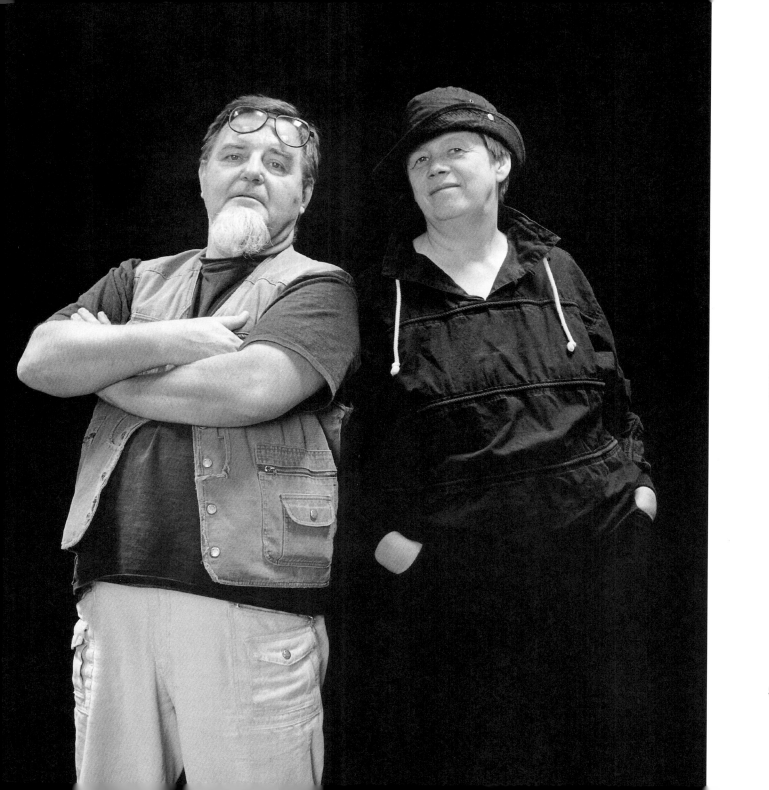

Steina and Woody Vasulka

MACHINE MEDIA

MUSEUM OF MODERN ART

STEINA AND WOODY VASULKA: MACHINE MEDIA IS PUBLISHED ON THE OCCASION OF AN EXHIBITION ORGANIZED BY ROBERT R. RILEY AND MARITA STURKEN FOR THE SAN FRANCISCO MUSEUM OF MODERN ART, FEBRUARY 2 – MARCH 31, 1996.

Steina and Woody Vasulka: Machine Media is made possible by a generous grant from the National Endowment for the Arts, a Federal agency.

Production Funding Credits: *The West* (Pl. 4): The Rockefeller Foundation; National Endowment for the Arts. *Borealis* (Pl. 6): National Endowment for the Arts. *The Brotherhood Table III* (Pl. 7): Ars Electronica; Kunst—und Ausstellungshalle der Bundesrepublik Deutschland. *Artifacts* (Pl. 11): New York State Council on the Arts. *Summer Salt* (Pl. 12): National Endowment for the Arts; New Mexico Arts Division. *The Commission* (Pl. 13): National Endowment for the Arts; New Mexico Arts Division. *Voice Windows* (Pl. 14): National Endowment for the Arts. *Art of Memory* (Pl. 15): New Mexico Arts Division; Western States Regional Arts Fellowship; National Endowment for the Arts. *Lilith* (Pl. 16): National Endowment for the Arts; New Mexico Arts Division. *In the Land of the Elevator Girls* (Pl. 17): Hirofumi Mora of Hitachi; U.S./Japan Friendship Commission; Atanor/Imatco.

Library of Congress Catalog Card Number: 95-71807
ISBN: 0-918471-35-4

Editor: Marita Sturken
Production Manager: Kara Kirk
Design and Typography: Michael Sumner/Burning Books
Design and Editorial Assistance: Melody Sumner Carnahan
Photo Credits: Unless indicated below, all illustrations are courtesy of the artists. PAGES 14–15: installation photograph and detail by Kevin Noble; PAGE 16: photograph of Steina by Peter Kahn; PAGE 25: photograph of Woody Vasulka by Peter Kahn; PAGE 68: photograph of Woody Vasulka by Peter Kahn; PAGE 73: photograph of Steina and Woody Vasulka by Bob Day.

Cover: Images courtesy of Steina and Woody Vasulka
Frontispiece: Woody Vasulka and Steina, 1993 (Photo © 1993 Mariana Cook)

Contents

Director's
Foreword

Steina and Woody Vasulka are primary figures in the history of video art, esteemed both as artists and as innovators in the development of imaging devices that have greatly expanded video's expressive capabilities. Drawn by the spirit of invention and sense of possibility they saw in the United States during the 1960s, they immigrated from Europe in 1965, settling first in New York, and more recently in New Mexico, where their individual and joint careers have flourished internationally.

San Francisco has long been a center for experimental sound, film, and video. When the Vasulkas came to the Bay Area in 1971 to undertake Rockefeller Foundation supported residencies at the Center for Experiments in Television at the public television station KQED, they found a community of peers interested in similarly creative approaches to technology. In recognition of the strength of this regional tradition, as well as the significant place these forms have found in the wider field of contemporary art, in 1987 SFMOMA established a department for the collection, exhibition, interpretation, and preservation of media arts, encompassing video, film, sound, and other time-based, electronic forms. This department, under the direction of founding Curator of Media Arts Robert R. Riley, has established a program that is dedicated not only to exciting new developments in the creative use of imaging technologies, but also to the now three-decade-old history of electronic arts.

It is a great privilege to be presenting this survey of the Vasulkas' work, *Steina and Woody Vasulka: Machine Media,* which features eight video installations and nine single-channel videotapes presented in three programs. We are indebted to the National Endowment for the Arts for their generous support of this exhibition and publication.

Tremendous thanks are due to the curators of the exhibition: Robert Riley, and Marita Sturken, who is an assistant professor at the Annenberg School for Communication, University of Southern California. They were supported in this endeavor by many members of the Museum's staff, in particular, former Director of Curatorial Affairs Inge-Lise Eckmann, Exhibitions Manager Barbara Levine, Curatorial Assistant Mark Petr, Media Arts Program Assistants Justin Graham and Luis Mendez, Media Arts Assistant Carol Nakaso, Head Registrar and Acting Director of Curatorial Affairs Tina Garfinkel, Associate Registrar Olga Charyshyn, and Kent Roberts and the installation crew.

I also wish to extend my deepest gratitude to the authors of this catalogue — Robert Riley, Marita Sturken, Maureen Turim and Scott Nygren, and Woody Vasulka — whose scholarship provides an exceptional complement to the exhibition. In addition, special thanks are due to SFMOMA Publications Manager Kara Kirk and Publications Assistant Alexandra Chappell, as well as to Michael Sumner, who designed this publication, and to Melody Sumner Carnahan, who provided design and editorial assistance.

The Museum is pleased to have in its collection a number of important works by Steina and Woody Vasulka, all of which figure in this exhibition. The other works featured are on loan from the artists themselves, and we thank them for their generosity.

We are obliged to Bruce Hamilton, technical assistant to the artists, for his contributions to this project, as well as to JoAnn Hanley for her role in the initial phases of conceptualizing the exhibition. In addition, on behalf of the artists, I would like to express special gratitude to Susan and Jamie Hamilton, David Dunn, Jeffrey Schier, Diana Dosch, and Flora Vasulkova.

And finally, an exhibition of such conceptual and logistical complexity could not have been possible without the collaboration of the artists themselves. For this we offer sincere thanks to Steina and Woody Vasulka and pay tribute to the creativity, experimentation, and commitment that informs all of their work. In both their artistic output and their unique exploration of new ideas and techniques, they provide models of artistic engagement that speak to the role of art in our society as we move into the twenty-first century. JOHN R. LANE

Steina
and
Woody Vasulka:
Machine Media

ROBERT R. RILEY

The complex arena of contemporary technology demands a multidisciplinary investigation of which art is a part. This exhibition provides timely consideration of video art in an era of electronic communications technology and shifting cultural contexts. Creating visual art with the mechanisms of the video medium — its technical apparatus, its sound and moving picture fields, the electronic signal — Steina and Woody Vasulka reveal and define the capacity of the medium to organize space, to influence perception, and to pattern thought. Central figures in the early development of video as an art form, the Vasulkas are particularly important today as they at times anticipate and pursue and at times conclude and summarize new directions in electronic art.

The artists' involvement in video, and their attraction to an "electronic palette," began in the late 1960s, an era characterized by experimentation and modernist approaches. Placing an emphasis on minimal structures and on the material itself — video's phenomenology — and recognizing the role of process

over product, the visual art of this period largely adhered to a rigorous belief in concept over commodity. The Vasulkas established a method of working that found electronic media not a fully formed utility, but one subject to interpretation.

Similar strategies were expressed by artists working in theater and in music, who invented forms and techniques relevant to the Vasulkas' concerns. Earlier developments in methods of electronic instrumentation and composition encouraged explorations in sound generation, setting a precedent for experiments in video and magnetic tape recording. Changes in theater production reshaped the stage to expose its mechanical apparatus as expressive content, and live performance began to be amplified with electronic sound and imagery.

Artists in the 1960s valued sweeping revisions; insight, innovation, and exploration were paramount. The notion of an "expanded cinema" defined video as an electronic proscenium of limitless potential. Such aspects of artistic expression influenced the growth of video as an artist's medium and helped to establish an independent movement of artists, practitioners, and engineers. Significantly, video opened for artists a new, electronically derived pictorial space, one seemingly uncompromised by either art history or established aesthetics.

Tracing the work of Steina and Woody Vasulka through historical and cultural perspectives allows us to examine their creative strategies, including their ongoing fascination with space. The Vasulkas' explorations of electronic image are conducted today, as they were in the 1960s, against a background of radical cultural and technological change. Today's global communications, and the worldwide proliferation in mainstream cultures of commercially available electronics, stand in marked contrast to the video artists' community of the late 1960s and early 1970s, which utilized low-budget, homemade, personalized electronic tools.

Though a range of commercial components and electronic recording devices existed in those early years, Steina and Woody Vasulka collaborated with other artists and engineers in the fabrication of unique electronic circuitry; they began to develop their own video tools and sound/image interfaces. Electronic sound recording, with its metaphysical merging of time and energy, introduced a possible shared affinity between the audio signal and the video image. Motivated by parallel desires — to design an audio stimulus that could generate electronic imagery, and to discover what instructions for generating those images the machine itself might require — the artists formulated a language based on the behavior of the electronic signal.

Working both collaboratively and independently, the Vasulkas established a lexicon of interrelated processes drawn from the machine itself. Guided by a critical investigation of the machine's function and application in art-making, they began to address the promise of utopia, as derived from media theoretician Marshall McLuhan's statement that television technologies are an extension of the human nervous system. With the understanding that knowledge begins at a source and spreads exponentially to other points, the Vasulkas attempted to find in video something analogous to knowledge, or to allow the medium to become a vehicle through which knowledge might be shared.

The opening of The Kitchen in New York City in 1971 was an outgrowth of the Vasulkas' interest in collaborative exchange, and their desire that community resources be shared by artists. The Kitchen soon grew into a center for experimentation in the fields of performance, dance, music, and video, creating new parameters for artistic expression, and creating new audiences that saw video art and its relationship to electronic technologies as a challenge to the avant-garde.

10

Video was initially presented in exhibitions that argued for the potential of visual art in technological forms. The early video exhibitions explored new criteria for works of art in the machine age, sometimes at the expense of a critical examination of the work and its aesthetics. Video art was often presented in terms of modified television sets. The Vasulkas purposefully avoided such iconic presentations of "the television tube," which were prevalent in the work of other video pioneers such as Nam June Paik and Wolf Vostell. Though the Vasulkas may share Paik's claim that the artist can interfere with the broadcast signal, his iconic use of the industrial console to carry cultural significance is incompatible with their intention and practice. The Vasulkas chose as their material the technology itself.

Video need not conform to a fixed perspective of representational art or traditional figuration since it presents the possibility of nonphotographic and nonfilmic images. Although contemporary vision continues to be influenced by the camera and its frame, it can be argued that in video the camera no longer dominates the narrative. Rather, narrativity is the result of the performance of the entire system. The question of machine protocol and machine autonomy also is central to the Vasulkas' project. The ontological system for recording and storage in video, and the manner of transmission of knowledge within a machine, are concerns that continue throughout their early multimonitor assemblies to their most recent machine constructions.

Video for the Vasulkas is a system of languages that proposes a new set of codes. Their work references the history of machines, and finds in machines capacities that are impeded or limited from the moment of design and manufacture. The Vasulkas' project is to investigate and release these capacities both as subject matter and as a critical yet celebratory text.

The Vasulkas have produced a body of work in dialogue with the tools of production as well as with the intricate systems of the information environment. They have done so in forms largely without established aesthetics or precedence in the art world. Steina and Woody Vasulka see the video image as incomplete, unfixed, subject to the processes of history, manipulation, and interpretation. Engaging the meaning of electronic language, exploring a new definition of space, the Vasulkas' work is fundamental to contemporary expression in video art and instrumental to the emergent fields of electronic media.

11

ROBERT R. RILEY

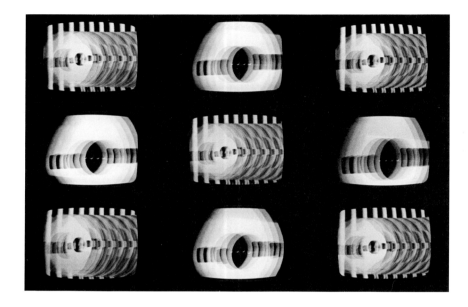

Matrix

1 Steina and Woody Vasulka
MATRIX 1970–72
installation view (above)

2 Steina and Woody Vasulka
MATRIX 1970–72
video still (right)

In the late 1960s and early 1970s, the Vasulkas were among early practitioners of video who experimented with video array formats. These multimonitor configurations, ranging from three to numerous video monitors arranged as freestanding stacks or wall-bound structures, were the convention by which artists' videotapes were exhibited in alternative media spaces such as The Kitchen. The video arrays were the first step toward artists thinking in terms of multiple channels of video and the installation format. The Vasulkas' *Matrix* series employs the expandable framework of the video array to examine specific aesthetic and technological concerns: the physicality of the image, the materiality of the passage of time, and the control and transmission of visual information.

Abstract in character, *Matrix* imagery is derived from the manipulation of the electronic waveform. The Vasulkas drift a series of images across the screens of the video array in order to demonstrate both the fluidity of the electronic signal and its capacity to move within and beyond the video frame. *Matrix* examines pure motion and process, emphasizing the way in which the single video image can be expanded exponentially to fill a multimonitor picture field. The pulse of the signal is revealed as visual and audio correlatives pass in sweeping gestures across the field of monitors to create, in effect, a large-scale figuration of the scanning mechanism of video itself. The sound in *Matrix* derives from the movement of electronic signals through machines: sound can generate an image, can itself be generated by an image, or both sound and image might be created simultaneously. The phenomenon of television is an appropriate metaphor for the *Matrix* installations: from a central location, information is distributed widely to a number of individual receivers, accumulating in an amplified form. — RR

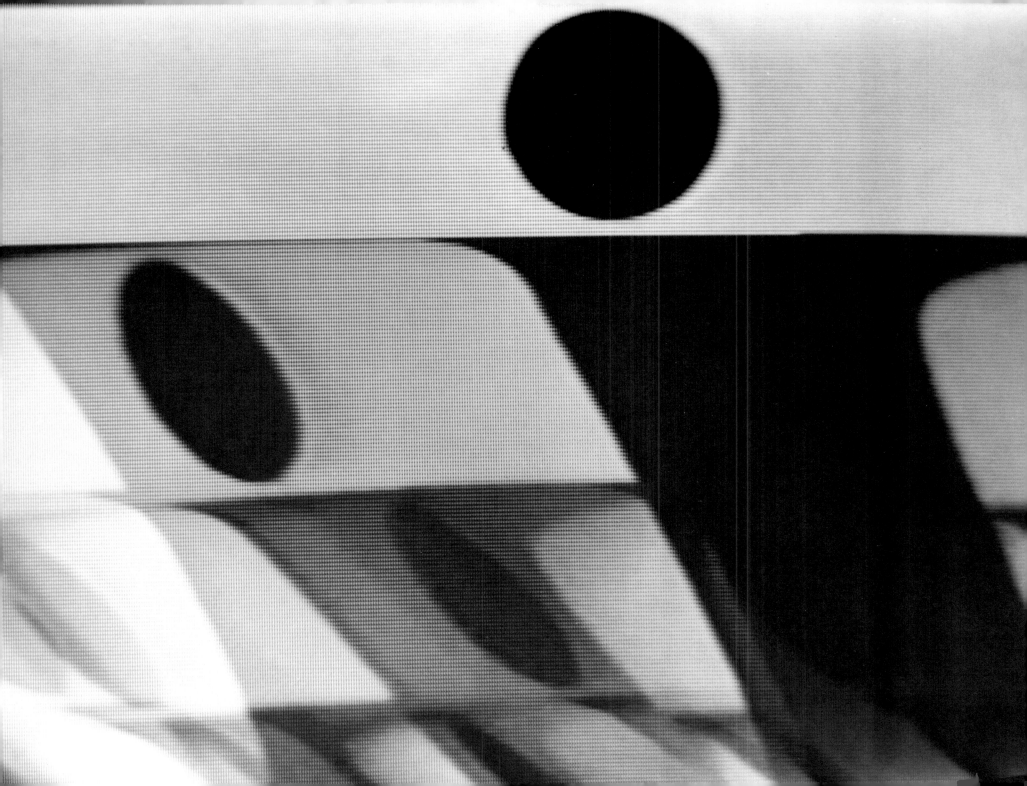

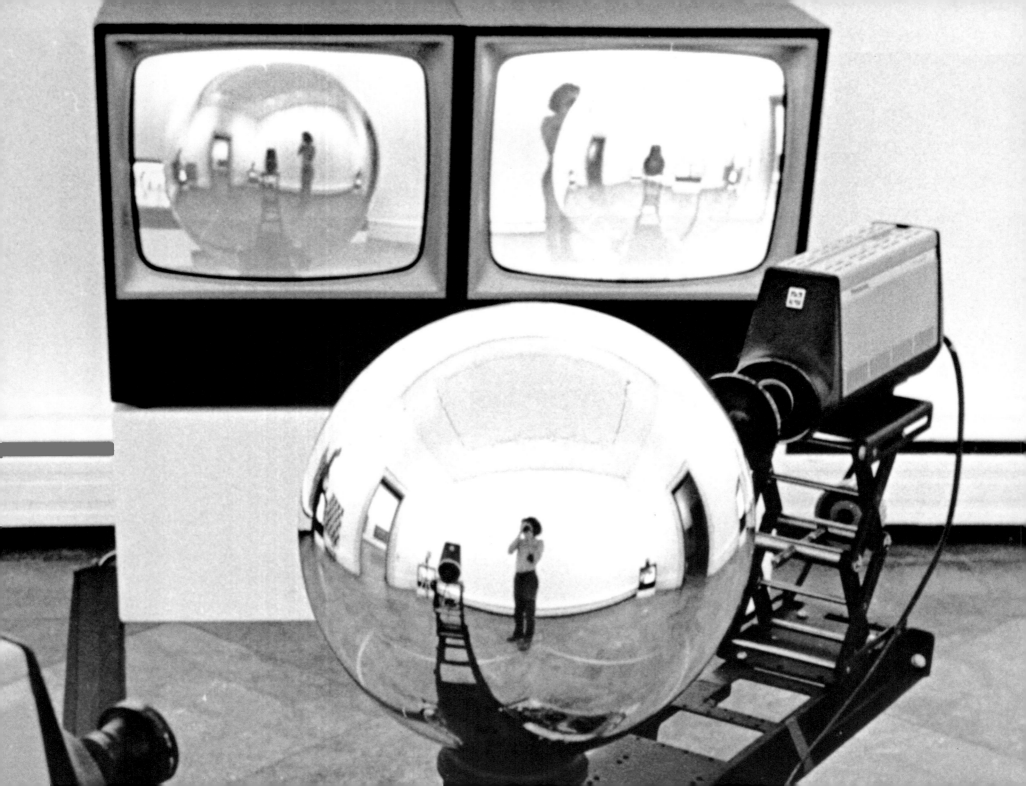

Allvision

Steina has been involved in the fabrication of video-imaging devices that are patterned after filmic camera movements such as the pan, tilt, and zoom. In 1975, she began an extended series entitled "Machine Vision," of which *Allvision* is a part. *Allvision* incorporates and transforms physical space through video. In this opto/mechanical installation, Steina transfigures the viewer's orientation; a constructed physical space is engaged in conversation with the perceptual systems of the human eye and the camera lens.

The mechanical apparatus of *Allvision* is placed centrally in an environment reflected in the machine's mirrored sphere. The focus of the two cameras, the sphere reveals the surrounding space as it rotates into view. This real-time surveillance system relays reflections of the environment and transmits them live via closed-circuit television into two adjacent video monitors placed in the same room. The video images create an original space, which incorporates the space in which the viewer is in fact situated, and at the same time allows the viewer to perceive a representation of that space made abstract, symbolic, and fluid as a result of the machine's rotational vision.

Allvision poses questions about the process of transcribing all-encompassing space and the ways in which perception can be altered or exaggerated by a mechanical interface. The machine allows a view of what would otherwise be impossible to perceive; it privileges vision to experience the implausible and fantastic. The transmission of real time in live video invokes performance art with its intent to break down habits of vision. Exuberant in its use of technology, *Allvision* renews visual pleasure as it expands the prescribed field of television by allowing not only the viewing of space made abstract and in motion but also a concrete experience of time. — RR

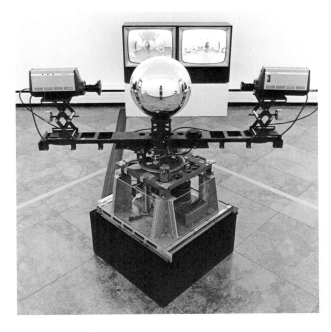

3 Steina
ALLVISION 1976
Installation view (left) and detail (opposite)

The West

4 Steina
THE WEST 1983
Steina with mirrored sphere (below)
Simulated installation view (opposite)

16

The West is a two-channel, video installation of twenty-two double-stacked monitors arranged in a semicircular curve. Within the arena of *The West*, the viewer is enveloped in color, motion, and sound as multiple video images converge within the gallery space to invoke an ever-changing symbolic horizon.

In creating her video landscape, Steina focused on the Southwestern United States, both as a mythology and a subject. To her, history is to be found in natural forms, and the ways they have been engaged and changed by human intervention. The West is represented in images that underscore mankind's uses of the natural environment: Steina recorded the imprint of mankind on the land through the spectrum of human technologies, ranging from Anasazi brick ruins to radio telescope systems, each a quest to understand the universe in some way. These images comprise a compelling narrative about the West ordered in musical passages that alternate in sweeping movement across the field of multiple monitors.

Many of the images in *The West* were recorded with a motor-driven camera focused directly into a spherical mirror—a device used in the installation *Allvision* and in several single-channel videotapes. The camera sees images of land simultaneously in front of and behind the lens, creating a circular area of optically transformed space centered in the otherwise rectangular shape of the video screen. Through the visual motif of horizontal drift, the framing edge of the single monitor is defeated to create the illusion of an image in sideways motion—like a long glance, scanning the environment in boundless perusal.

The installation environment is enhanced with a four-channel audiowork, created by Woody Vasulka, which is fully integrated with the video. Rendered in maximum saturation, the electronic video color is a complement to the austere desert light. *The West* accomplishes a poetic vision, evocative of the place and its history, an eloquent exploration of the passage of time and the merging of land and technology. — RR

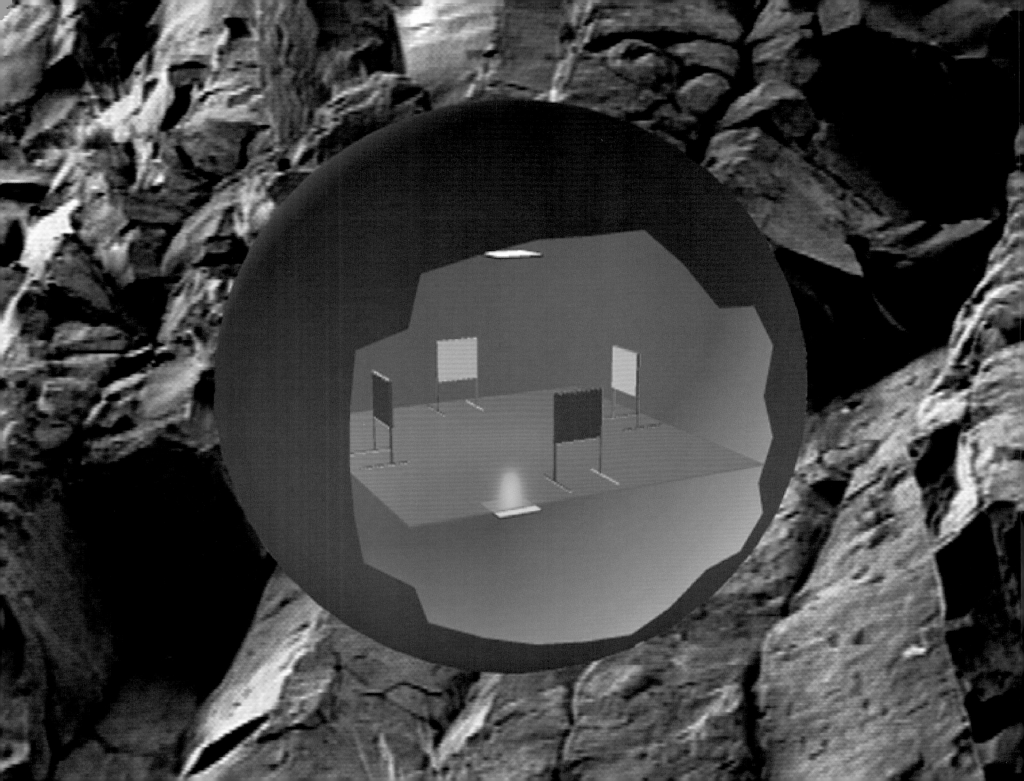

Theater of Hybrid Automata

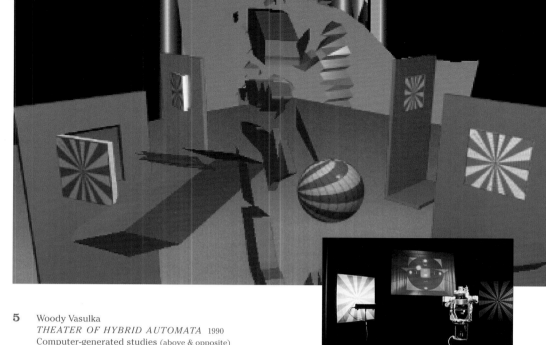

A new departure for Woody has been an aesthetic investigation of the structures of the new "space" that electronic technologies have introduced — a space that is both omnidirectional and potentially noncentric. *Theater of Hybrid Automata* examines the ritual of the machine, made from analog and digital tools of diverse origins, as it seeks its identity through calibration. With these tools, Woody models an environment that displays a dynamic combination of the rules and procedures of machine protocol.

Theater of Hybrid Automata contains patterns of perception in the form of a three-dimensional model with which it navigates "outer" space. The cube-like apparatus of the "theater" is confined inside a room-sized framework, forming a stage in conversation with the surrounding space. Comprised of various instruments, such as a 360-degree rotating camera apparatus, projection devices and screens, laserdisc players, and infrared sensors, its numerous parts are mediated by a computer. Fully interactive within itself, *Theater of Hybrid Automata* appears to assume intellectual supervision of itself, thereby controlling and implicating image-making in a space that is at once virtual and physical.

In operation, the sensitive instruments of the theater guide the movements of a camera in an exploration of the theater's enclosure. Six targets placed at the four cardinal points as well as above and below help the camera locate itself as the center of the configuration. The camera, which "reads" the terrain of targets and imaging tools, begins to write its own set of self-exploratory instructions. Relationships between the program and the environment are defined, and then organized as allegory, narrating the

5 Woody Vasulka
THEATER OF HYBRID AUTOMATA 1990
Computer-generated studies (above & opposite)
Installation view (right)

ways in which virtual space might be visualized by an intelligent, mechanized media. Thus the work creates a dramatic space as it relates to itself, following the principles of closed-system operation. A self-conscious machine with the power to vocalize what it sees, *Theater of Hybrid Automata* defines, through its targets and indices, locations relational to its own technological body. It derives its content from the boundaries of the constructed space, as well as from the rules of syntax and narrativity.

Theater of Hybrid Automata raises questions about place, identity, and knowledge. It examines the virtual within the actual, as well as the actual within the virtual, enacting a physical stage for the computer's representation of space. — RR

19

Borealis

Video can be seen, in many ways, as a means of surpassing the ambitions of twentieth-century abstract painting to exceed frame boundaries and to create multiple temporalities. Steina's *Borealis* emphasizes the fluid quality of the electronic image and the ways in which content and form in video are often inseparable. In *Borealis,* video is not just a thing to observe but an environment born from the physical presence of light, sound, and electricity.

Borealis is a large-scale, two-channel installation involving four freestanding translucent screens and two video projectors, each fitted with a mirror device that divides the imagery onto the screens. The images illuminate both sides of the screens and appear to float in a darkened room. The natural sounds and the images of *Borealis,* recorded by Steina in Iceland in 1992, overwhelm the environment in which they are placed, emphasizing the magnitude of nature. The viewer, swept into a meditation on the patterns of natural processes, is led to question the static ways in which landscape is usually represented.

With its continual surge of water, waves, and foam, its vapor and mists in recurring patterns, *Boreali*s evokes the force of nature as a persuasive narrative that threatens to obliterate all sense of permanence. This suggests other principles at work in Steina's attraction to the medium: her interest in inspiring revelations about the time-based and impermanent dimensions of video itself; and her desire to offer new experiences to the viewer, guided by an ongoing investigation into fugitive sensory phenomena. — RR

20

6 Steina
BOREALIS 1993
Simulated installation view

The Brotherhood, Table III

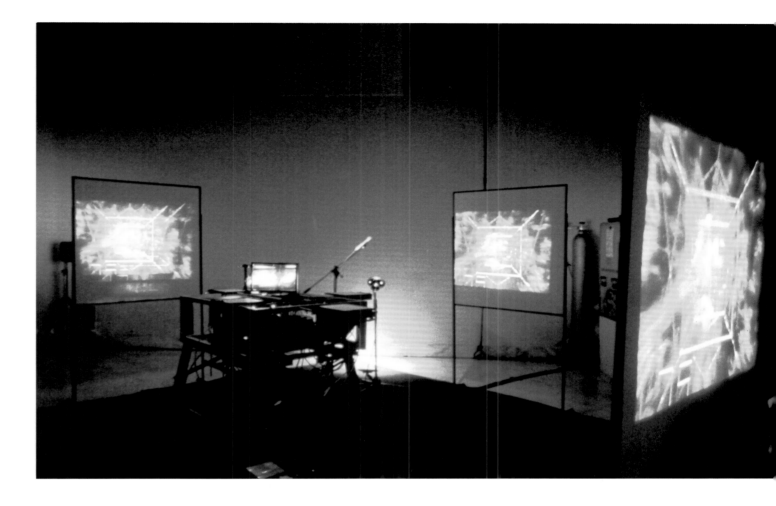

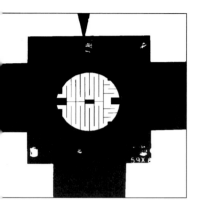

7 Woody Vasulka
THE BROTHERHOOD, 1994–96

TABLE III, 1994
Installation view (right)
details of found circuitry (opposite)

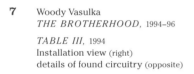

The volume of information in contemporary media is ever increasing. Woody Vasulka has crafted, from an arsenal of film and video machines, cameras, optical and electronic devices, with original command and control programs of the computer, an expression of a congested, concrete space that these technologies seek to defy. *The Brotherhood* series reveals the artist's concerns with the way technology determines human conduct and literacy. His radical constructions of machines and image-making procedures, while relevant to the "information age," are concerned with history and the nature of intelligence.

Woody's recent structures, such as *Theater of Hybrid Automata* and *The Brotherhood* series, mark an important departure from his earlier investigations into the image as object to an exploration of the image as an indicator and function of space. Built largely of

23

ROBERT R. RILEY

INSTALLATIONS

surplus material from military and scientific salvage yards, both obsolete and current technologies, *The Brotherhood* tables form transliterate conversations between the human, the mechanical, the technical, and the social. The opto/electro/mechanical features of each construction are reconfigured as a "table" — a horizontal landscape of instruments and procedures — to explore spatial dynamics, and image and object as a form of narrativity.

These two works, *Table I* (1996) and *Table III* (1994), are interactive tables that integrate recording mechanisms and video projection apparatuses as forums for a modernist preoccupation with the machine, its function and effect. Each evokes the paradox of the explicit use of electronic media in both art and the arenas of the military and science. The title of the series implies a set of ethics, a consensual or secret code of technology usage, one which is predetermined to dictate its own aesthetic and function. *Table I* is made from a plotting table that Woody suspects was a wartime tool to chart air interception. Its original application involved a graphic function to locate targets and to ultimately defeat or map motion, transport, or attack. The actual machine suggests to the artist a form of pictorial memory rendered as calibration. In revising the machine as a sculptural component, he repositions integrated circuit designs and electronic charts in a conceptual model. His artwork examines a cycle of operations and calculations as an ironic text regarding control and the conspiracy of the male mind.

The Brotherhood's rhetorical acuity invites the viewer to perceive the operatives of computer-controlled images and environments. Woody creates impressions that suggest restrictions in the electronic field, which while organized on the principle of limitless potential, are imposed by the machine itself. *Table III,* found at Los Alamos National Laboratory, became the inspiration for the entire series. Woody believes it contained computers developed to release bombs on targets during the Vietnam War. From this table

8 Woody Vasulka
THE BROTHERHOOD, 1994–96

TABLE I, 1996
Woody at work on *Table I* (left)
computer-generated imagery (opposite)

he expands the work's dimension to a cube defined by screens and projected images as its outmost surface. Invoking his desire to make spatial — or environmental — his theme of violence, the installation reinforces the function of a centrally constructed space in order to determine the rules of that space as a means to depart from it. *Table III* allows the viewer to interact with the projection of imagery and affect the operation of its machinery. Significantly, Woody's preoccupation with the image and how a narrative system can survive and remain critical underscores the work. *The Brotherhood* generously uncovers what is perhaps the underlying agenda of all machine media — the artist's need for individuation and vigilant exploration of a technological medium for art and visual communication. — **RR**

25

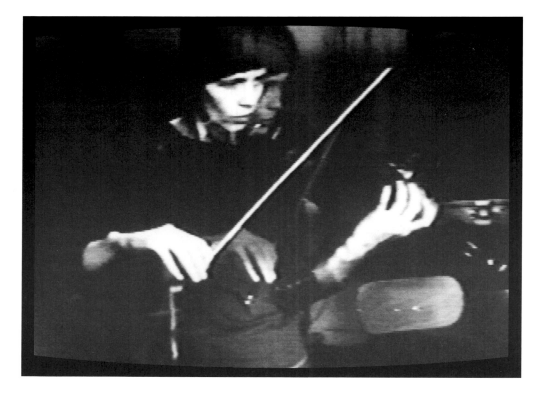

Violin Power

9 Steina
VIOLIN POWER 1970–78
Video still

Violin Power is Steina's "demo tape on how to play video on the violin," a serious joke on the relationship of the video camera to musical instrumentation. This videotape operates both as an autobiographical tracing of Steina's replacement of the violin with the video camera for her primary instrument and as a systematic exploration of the relationship between electronic sound and image. The "power" of the violin is its capacity, when electronically wired, to alter and generate video imagery — in effect, to co-create Steina's electronic images.

After opening with Steina's parodic performance of classical music, a sequence shot in 1970, the videotape presents her well-known, macro view of herself lip-syncing The Beatles' song "Let It Be," a humorous homage to the power of rock music that predates more recent popular forms of lip-sync performance. Steina plays her "wired" violin through a series of electronic devices that directly alter the video signal by utilizing signal disruption, video keying, and a scan processor. The movement of her violin bow across the strings of the instrument disrupts and transposes the video image, causing the violin bow to appear to squiggle and snake into interlocking waveforms. The alliance of sound and image in the electronic signal allows the audio vibrations of the violin to create image disruptions. The violin is thus a means through which electronic sound can be spatialized to create an image performance. — MS

Orbital Obsessions

10 Steina
ORBITAL OBSESSIONS 1975–77, revised 1988
Video still

Steina's "Machine Vision" project, which she pursued throughout the 1970s, is an investigation into the capacity of electronic machines to reorchestrate space. In the mid-1970s, she produced a series of vdeotapes that combine mechanical and electronic elements to rethink the video camera's relationship to space. In these works, her image material is her equipment-filled studio in Buffalo, New York. *Orbital Obsessions* combines excerpts from *Signifying Nothing* (1975), *Sound and Fury* (1975), *Switch! Monitor! Drift!* (1976), and *Snowed Tapes* (1977) to present an excelerated view, so to speak, of the developments of Machine Vision.

The elements of *Orbital Obsessions* are both self-evident and densely layered, presented in a casual style that almost masks a rigorous refiguring of space. Steina begins by placing the video camera on a turntable and then walks through a series of processes, each of which takes the image further from its original static frame. Several cameras scan each other, keying devices layer images, and a flip/flop switcher rapidly switches between two camera views. Throughout these works, Steina places her body as image material within the frame, leaning into the camera, swaying back and forth, and moving in a quasi-choreography through image space. These Machine Vision videotapes thus constitute "acts" in a process to rethink electronic time and space. In each, the real-time aspect of the tape creates an experience for the viewer of phenomenological time — the viewer learns at the same pace as Steina how each added device will further complicate the image. The "obsessions" of *Orbital Obsession* are its preoccupations with the circularity of the video camera's visual orbit and the means by which the mechanical informs and enhances electronic media. — MS

Artifacts

Artifacts is both a document of the capacities of the Digital Image Articulator, a device Woody designed in the late 1970s with Jeffrey Schier, and an aesthetic interpretation of the potentials of digital image language. Woody presents the work as evidence of his collaborative relationship with the machine. "By artifacts," he states in the videotape, "I mean that I have to share the creative process with the machine. It is responsible for too many elements in this work. These images come to you as they came to me — in a spirit of exploration."

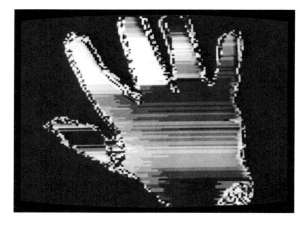

1 1 Woody Vasulka
ARTIFACTS 1980
Video stills

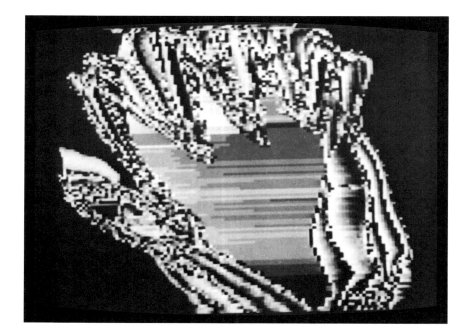

The image forms generated by the Digital Image Articulator are based, like all digital images, on algorithmic prodedures that transpose visual elements into mathematical components. Woody demonstrates the capacities of digital imaging in an eclectic and informal fashion, using a spherical shape and his hand as basic "artifacts" that the image device converts into compellingly alive digital forms. These transformations are performed in "real time," so that the viewer sees the image created in a performative mode rather than as the final product of a lengthy image process. A primary element in Woody's "dialogue with the machine" is that the image itself reveals the process of its construction. *Artifacts* marks the Vasulkas' collective step into digital imaging and an examination of the relationship between analog and digital. With the image of Woody's hand as its primary motif, *Artifacts* is a work that reflects on the history of craftsmanship and the human hand as a source of creativity: the hand that molds, in tandem with the digital machine, the forms of electronic space. — MS

28

Summer Salt

Summer Salt marks for Steina a continuing exploration of the phenomenology of space, yet with a shift in image material. Here, Steina transposes her explorations of "Machine Vision" from her studio to the landscape of New Mexico, to her backyard's realm of earth and sky. *Summer Salt* is emblematic of her melding of self-humor and physical jokes with systematic reconfigurings of the physical within the electronic. This work is an exploration of physicality — the body within the camera frame, the actual body of the camera itself, and the physicality of material space within the spheres of electronic space.

Each section of the videotape builds upon the previous one to create an increasingly multifaceted sense of spatial dimensions. In *Sky High,* the camera is attached to the roof of a moving car with a mirrored lens that creates close to a 360-degree "distortion" of the New Mexican sky, curved into a spherical merging of landscape and horizon. *Low Ride* takes the camera to the opposite extreme, with it strapped to the front bumper of the car as it drives through desert bush. The bumping, scraping, and scratching of the camera on the prickly desert plants and sandy dirt exposes the body of the camera itself, with its built-in microphone, banging into its subject matter — an aspect of camera-generated images that is usually hidden from the image. In *Somersault,* Steina playfully does gymnastics with her camera and its mirrored lens attachment as a means of producing a 360-degree image of a torso wrapped around

12 Steina
SUMMER SALT 1982
Video still

the camera lens. As she spins the camera and bounces it off her hips in a humorous joke on the material nature of the camera, she creates a kind of slapstick about the notion of the camera as an extension of the body. *Rest* allows the camera to rest in a hammock, exhausted, in effect, from its physical exertions, as Steina digitally refigures the surrounding trees. Finally, in *Photographic Memory,* seasonal landscapes are interwoven, shifted, and layered in sequences that insist on the tension between moving and still image. *Summer Salt* thus traces Steina's merging of analog and digital tools, and her project to strip the camera down to its essential physical nature. — MS

29

The Commission

13 Woody Vasulka
THE COMMISSION 1983
Video still

A prototype for a new form, the "electronic opera," *The Commission* represents the capacity of electronic media to create narrative through visual codes and digital effects. Woody's dual purpose in this work is to use digital processes to produce a vocabulary of electronic language, and to examine the mythologies that infuse the role of the artist. He chose the rivalrous relationship of two musicians, Hector Berlioz and Niccolò Paganini, as his romantic and tragic subject. The story centers on a commission a patron wanted Paganini to present to Berlioz. Paganini, whose role is interpreted by video artist Ernest Gusella, represents the flamboyant yet destitute artistic genius, a pariah rejected by the church; whereas Berlioz, interpreted by performer/composer Robert Ashley, is pompous and detached, the artist as ego.

Yet, Woody's central purpose is not to tell this story but to examine how narrative elements can be visualized through digital media. He wants to subvert narrative into antinarrative strategies, to expose its framework. In each of the tape's eleven segments, a

different effect is deployed for specific narrative meaning: the echoes of Paganini's music are depicted in pixilated digital shadowings, a flip/flop device creates tension when Paganini passes the commission to Berlioz by rapidly switching between views of each, and a scan processor gives a skeletal effect to Paganini's corpse as it is embalmed.

The Commission provides evidence of a language of electronic image codes, one for which Woody has spent years working to formulate a "vocabulary." The primary story it tells is an image journey, a mapping of the potential of the digital image, through which the ephemeral, the emotional, and the peripheral can be evoked. — MS

30

Voice Windows

Voice Windows builds on Steina's earlier performance works, such as *Violin Power,* as it investigates the essential relationship of electronic imaging to the space of sound. The voice of avant-garde composer and performer Joan La Barbara forms the videotape's guiding image device in a work that aims to actualize the physicality of the human voice. Here, La Barbara's voice creates a "window" from one landscape, the open desert, to another, the city of Santa Fe. This process builds throughout the tape, beginning with a simple grid of musical scales that offers a glimpse onto a new landscape with every note and then moves into more complex layerings. As La Barbara sings, hums, chirps and chants in a form of half-song almost-speech, her voice is the device that interfaces with the landscape, distorting shapes, and creating new forms.

Voice Windows reveals the capacity of sound to reconfigure image and the malleability of the electronic signal as image/sound. This work demonstrates the fundamental alliance of sound and image in electronic media, each derived from the electronic signal and symbiotically part of the other. Here, the energy of the human voice reshapes geology and creates new spaces. — MS

14 Steina
VOICE WINDOWS 1986
Video stills

Art of Memory

15 Woody Vasulka
ART OF MEMORY 1987
Video stills in simulated environment

Art of Memory is both a reflection on the discourse of history and the fragmentary experience of memory, while at the same time it explores the potential of the electronic image to become an object and depart from the two-dimensional video screen. This compelling work, which is comprised of image forms that radically redefine the electronic image, is concerned with the transposition of the photographic and cinematic into the electronic.

The subject of *Art of Memory* is the catastrophic events through which twentieth-century history has been defined — the Spanish civil war, the Russian Revolution, World War II, the nuclear bomb — and, by extension, the images of those events formed in cultural memory. Woody creates three-dimensional digital forms through which these images of history are transformed until they can only be read as elements in the cacophony of memory, as shredded bits of time. He places these forms within video images of southwestern landscapes, enveloping yet not swallowing the images of the past. *Art of Memory* reflects on the fragmentary yet powerful capacity of memory to resurge, to present the voices and images of the past in new media with new meanings, and to reconfigure the present. Images of the past haunt this work, speaking to the legacies of these violent and cataclysmic events. *Art of Memory* foregrounds the role of the camera in creating history, and reveals the capacity of electronic media to build upon and finally usurp the phenomenology of the media that preceded it. — MS

32

Lilith

The landscape of the human face and the mythical status of earthly forms and their spiritual shadows provides the impetus for *Lilith*. Here, Steina treats the face of painter/poet Doris Cross as a canvas onto and through which a forest scene is realized. Lilith is a mythical figure, whose many roles and meanings are evoked in Cross's strange gestures and expressions. Lilith is the first wife of Adam, a witch or menacing female figure with mythical powers. In *Lilith,* Steina is clearly paying tribute to the complexity of the aging female face, its lines and expressions indicating experience and the marked terrain of a lived body.

At the same time, *Lilith* can be situated within Steina's tradition of rethinking landscape and reconfiguring space. Steina deploys an array of analog techniques to merge Cross's face with the landscape, to key it into and within its surroundings so that it too is a field onto which image elements are mapped. Cross's haunting, slowed speech, which Steina manipulates into abrupt half-sounds and guttural utterances, evokes a primordial presence. The Lilith of this work is finally a figure of enigma: difficult to read yet commanding attention in her merging of earth and human form. — MS

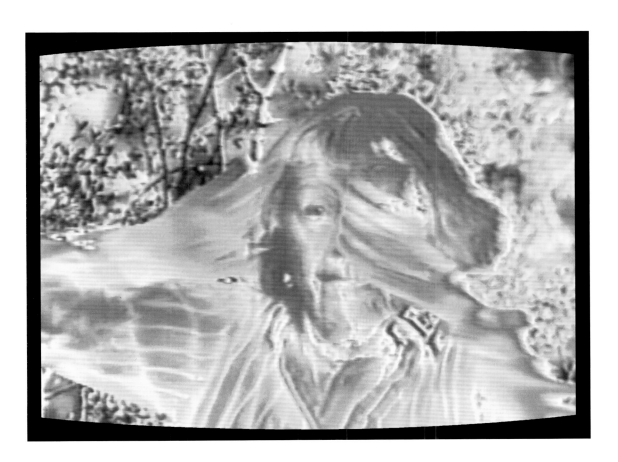

16 Steina
LILITH 1987
Video still

In the Land of the Elevator Girls

In the Land of the Elevator Girls is a travelogue through the land of electronic imaging in which geographies can be transcended and the images of electronic media offer glimpses into other, possible worlds. Steina takes as her first level of subject matter the urban-scape of Tokyo, where young women, known as "elevator girls," offer introductions to the various floors of elaborate department stores. In Steina's work, the elevator girls offer their polite phrases of greeting and departure as the elevator doors open first upon crowds of shoppers, and then upon landscapes, performance rituals, and urban scenes. Thus, at the moment when an elevator girl announces an arrival and the doors open upon a steaming volcanic landscape, the viewer is unexpectedly transported through the doors into another geographic realm.

The elevator doors, in both the original image and digital remake, are the means through which the viewer and Steina, as outsiders, are allowed to catch glimpses of the rituals of Japanese culture — from time-honored traditions, such as a Shinto ritual, to more recent ceremonies, such as a virtual reality demonstration. A primary subtext of the tape is the fact that elevators are now auto-mated, hence the elevator girls remain, not through necessity but as a vestige of cultural norms in which the transition from one space to another is announced and accompanied by a "guide." This threshold, marked by Steina through the motif of opening and closing doors, represents the movement not only between cultures but from analog to digital space, from inside to outside, and from commercial urbanscape to rural landscape. While offering a sense of the role played by the foreigner peering in at Japanese culture, *In the Land of the Elevator Girls* is primarily a visual enactment of the passage from one world to another. — MS

1 7 Steina
IN THE LAND OF THE ELEVATOR GIRLS 1989
Video still

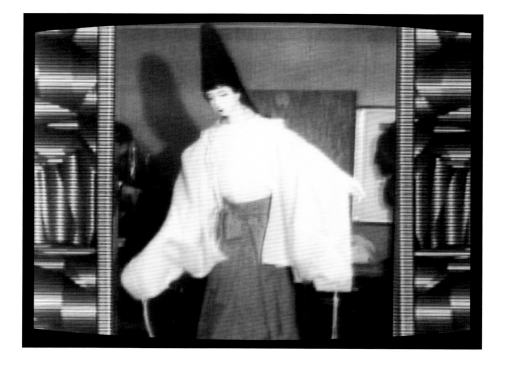

34

Steina and Woody Vasulka: In Dialogue with the Machine

MARITA STURKEN

Machines have been commonly regarded as antithetical to the spontaneity and originality of the creative process. Deep ambivalence pervades cultural attitudes toward the machine, and Western cultures often portray the late twentieth century as an era of technoculture in which the human condition is mediated only through machines. Hence, the machine figures significantly in the collective imagination, prompting various questions: Do machines enable a creative process or do they limit and structure human integrity? Are computers replicas of human thinking or crude versions of creative thought?

The machine has often been a central and controversial subject in the history of art in the twentieth century. For modernists, the machine was a source of aesthetic pleasure, testimony to the seductive narrative of progress and the beauty and tactility of the mechanical. The mechanical machine was modeled after the human body, its various components assigned roles as specific organs and limbs in an effort to mimic the efficiency of the human model. The mechanical machine defined the future.

In the 1960s, the use by artists of electronic tools in the production of art pushed cultural attitudes about the relationship of technology and art into new territory. Electronic technology raised concerns about authorship, artistic integrity, and the "taint" of mass culture. In the late twentieth century, proclamations about both the promise of technology in its increasingly global reach and concerns about its potential to increase alienation are reiterated with little understanding that they reflect time-worn ways of thinking about the question of technology. The notion of a thinking or artistic machine troubles entrenched cultural oppositions of technology versus art and technology versus nature, precisely because the concept of machine agency forces a rethinking of human agency itself.

For Steina and Woody Vasulka, the creative process represents a "dialogue with the machine," in which they are not masters of a tool but interpreters of its capabilities. Woody has said, "I have to share the creative process with the machine. It is responsible for too many elements in this work."[1] The Vasulkas' artwork can be positioned at the juncture of the mechanical and the electronic machine, posing crucial questions about the

35

capacities of machines, the language of electronic syntax, the phenomenology of visual media, and the spatiotemporal dimensions of electronic space.

In the multimonitor installations and single-channel videotapes that they have produced collaboratively and as individual artists for twenty-five years, the Vasulkas have systematically pursued two allied projects: an investigation of the agency of the machine and a phenomenological project of mapping the intrinsic properties of electronic media as they affect the viewer. Their work stands not only at the juncture of the mechanical and the electronic, but also between modernism and postmodernism. One could define it as a modernist project—to define the aesthetic language of a specific media and to distinguish the properties of those media in relationship to other systems of visual representation. Yet, in their continuing investigations into the tenuous nature of authorship in the context of the machine, their work can also be seen as a postmodern questioning.

While they have worked collaboratively as an artistic team, the Vasulkas have produced two very unique bodies of work with separate though allied agendas. Their interests in electronic media began with different perspectives. As a former filmmaker, Woody was initially driven to deconstruct electronic media in order to distinguish it from the codes of narrative cinema. His work has evolved from an interest in electronic language and image vocabularies, to a project of understanding the relationship of the image to the object, to a current concern with the protocol of machines — how machines interact among themselves without human contact. As a violinist, Steina began by treating the mechanisms of the camera as an instrument, a tool through which movement and spatial relationships could be examined. Her work has focused on reorchestrating space and landscape and translating to video the movement of natural processes.

The Vasulkas can both be situated as artists whose vision of the potential of electronic media was molded at a very particular moment in the relationship of art and technology. In the "utopic moment" of video's emergence as an artistic form in the late 1960s, cultural, social, and political unrest converged in the United States in such a way that social structures appeared mutable and artistic rules were defied.[2] As recent immigrants to the United States in this historical period, the Vasulkas saw the emergence of the video form as a radical means to rethink previously held truths about language form, the photographic real, the structure of narrative, and the role of the machine.

While this was a time of artistic and social upheaval, it was also a time of intense grass-roots technological activity and utopian notions of the possibility of refiguring the power relations of technology. The Vasulkas worked with a community of engineers and artist-engineers, such as Eric Siegel, George Brown, Steve Rutt, and Bill Etra, among others, to design tools that could "open the box" of technology and that were as much about redefining the designer-user relationship as they were about experimenting with the potential of media outside of the limitations of commercial devices. It is testimony to the power of that historical juncture that the Vasulkas' work has never lost its ability to convey a sense of possibility in its exploration of the electronic machine.

VIDEO AND THE LEGACY OF CINEMA
Unlike most other video practitioners, Woody began his investigations into video by confronting its formal differences from film. The specter of cinema looms over considerations of video's phenomenology as a medium. Video inherited from film certain codes of moving images: camera movement, editing techniques of montage and decoupage, and the frame. However, the electronic nature of the video medium irrevocably distinguishes it from the photographic nature of cinema. Woody states, "Each medium of the future will play host to the phenomenology of the moving image, which will live through that medium to the next medium, accumulating the language of each."[3] Nevertheless, as viewers we bring deeply

embedded and very different cultural associations to film and video. Despite its role in producing "historical" images, the electronic image is often coded as the immediate, instantly transmitted, live television image, and the cinematic image, especially in black-and-white film, is coded as history. In the 1987 videotape *Art of Memory* (pl. 15), Woody points to this distinction when he places black-and-white photographs and films of the Spanish civil war and World War II against a video tableau of the Southwestern landscape. Here, the framing video image marks the archival film image as a relic of history, a fragment of the past contained within the present.

In their early experiments with video, the Vasulkas were interested in manipulating the electronic signal without actually generating camera images. In this way, they felt they could explore the properties of video apart from the legacy of photography and film. This meant, above all, focusing on the electronic signal, its rendering in both sound and image, and its malleability. Many of these early experiments involved playing images across banks of monitors, in both a casual engagement with the aesthetics of multi-monitor matrixes as well as an early interest in the capacity of the video image to travel out of the monitor frame and across an array of screens. The Vasulkas felt that the fact that image and sound in video were inseparable (whereas in cinema they are recorded separately and only combined in the final print) offered an important aesthetic and technological break with the past. They produced a number of works in which both images and sounds were derived purely from the machine. The 1970–72 work *Matrix* (pls.1–2) exemplifies these

early experiments in which shapes and forms metamorphose across multiple screens as a means of depicting sound traveling through geometric space to our ear. Here, the Vasulkas realize sound visually by interpreting its movement. The matrixes serve to redefine the video frame by extending the image across its perceived boundaries and to realize fully the electronic alliance of sound and image.

The examination of the video frame has been a central aspect of Woody's project to distinguish film and video. The cinematic image is constructed of individual still frames that are recorded and projected at the speed of twenty-four frames per second. Whereas film is rigidly structured on the frame, the video image is not technically confined within the frame. For Woody, the video frame must be released from the rectangular frame of the viewfinder:

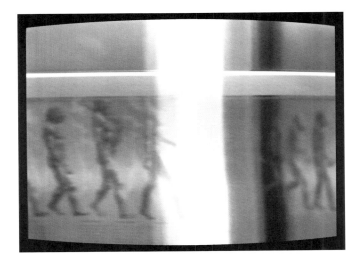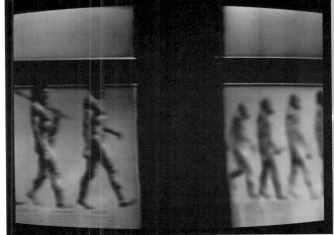

FIGURE 1 Steina and Woody Vasulka
EVOLUTION 1970
Video-still sequence showing horizontal drift

37

I recognize video as frame-bound and frame-unbound. In frame-bound video, you're basically following the cinematic reliance on the frame. Cinema can't leave the frame unless it makes a special effort. But with the new generation of tools in digital video, it is possible to remove the image from the frame and treat it as an object.[4]

The frame-unbound video image can appear to lift off the video screen and can be reshaped into an object, like the archival images in *Art of Memory*. It is thus divorced from its photographically defined role as a depiction of reality.

Woody notes that the film frame is essentially vertical, while the video frame is horizontal. One of the Vasulkas' first experiments with the video image was to release the video frame from its standard position and allow it to move horizontally — a technique they call "horizontal drift." Their early videotape *Evolution* (1970) humorously uses horizontal drift to comment on the notion of the development of moving image technology from praxiscope to film to video to computer image (fig. 1). In this work an image of the standard evolution chart of human development (the image of Cro-Magnon man and Homo sapiens so ingrained in our memories) is released so that it moves backward, rewinding across the frame and in time. Since this early, rudimentary work, the Vasulkas have deployed horizontal drift as a central visual motif, in particular to create image compositions that move across multimonitor installations.

ANALOG AND DIGITAL: QUESTIONS OF LANGUAGE

Since the mid-1970s, several tools have been influential in the Vasulkas' aesthetic as both instigating factors in and receptors of their style. The Rutt/Etra Scan Processor (designed by Steve Rutt and Bill Etra), which the Vasulkas acquired in 1974, is a device that reduces the electronic image to the component scan lines of the electronic waveform, rendering a topographic effect to the imagery (fig. 2). When an image is seen through the scan processor, it is reduced to its electronic waveforms (the basic element of the video signal), forming a kind of skeletal image; the light density of the image is spatialized (the bright areas of the image are raised, the dark areas lowered) and rendered three-dimensional. For Woody, the scan processor is a central tool in establishing a vocabulary of electronic images; for Steina it is an important aesthetic and deconstructive device. It allows both artists to strip the electronic image down to its essential components, and, as such, it offers a means to deconstruct the nature of the video image apart from its capacity to register the "real."

For these reasons, Woody saw the scan processor as the first step toward understanding the "code" of an electronic language.[5] This attempt to use a model of language for understanding the construction of electronic media inevitably led Woody to design his own machine. In 1976, he began working first with Don MacArthur and later with Jeffrey Schier in Buffalo, New York, to build what became the Digital Image Articulator, designed specifically to digitally process imagery in real time. At this time, electronic media was hovering at the juncture between the analog and the digital. The construction of the Digital Image Articulator was a step from analog (in which manipulation of the image is produced through the regulation of voltage changes and can be changed through "knob twisting") to digital electronics (in which the electronic signal is constructed in discrete picture elements, or pixels, and then mathematically stored so that it can be sampled at different intervals). Its construction was a laborious process; its various stages are documented in Woody's *Artifacts* (1980), and in Steina's *Cantaloup* (1980) and *Digital Images* (1979). Yet, while it represents a major technological and aesthetic step for the Vasulkas, it is not one in which the digital replaces the analog. Rather, each image form reflects and builds on the other, serving as testimony to different kinds of malleability. For Woody, the precision of the digital image both inspired and dictated an exploration into the vocabulary of images. The electronic language he envisions is mediated through the machine.

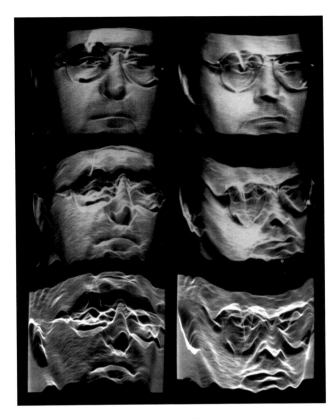

FIGURE 2 Woody Vasulka *DIDACTIC VIDEO* 1975
Video stills showing the effects of the scan processor

NARRATIVE FORM AND ANTINARRATIVE STRATEGIES

From these concerns with an electronic vocabulary, it was perhaps inevitable that Woody would turn to the issue of narrative structure. Similar to the capacity of the Digital Image Articulator to create an image from pixel fragments, narrative structure is the way in which we give our experience meaning. The narrative form, with its elements of climax, closure, and cause and effect, is not intrinsic to human experience, rather it structures fragments of memory. Elements of narrative hover over all forms of visual representation. While the Vasulkas' early works have been primarily viewed as didactic and formal statements on the possibilities of electronic imaging technology, they are also replete with narrative elements. The highly manipulated images of the Moravian landscape in Woody's videotape *Reminiscence* (1974) forms a narrative tracing of Woody's memory, a re-seeing of the past through the murky veil of the present. Certain elements are highlighted via the scan processor—drawn out like memories and made three-dimensional and vivid—while others recede. In the videotapes of Steina's "Machine Vision" series, including *Signifying Nothing* (1975) and *Switch! Monitor! Drift!* (1976) (which are excerpted in a later work from 1988, *Orbital Obsessions* [pl. 10]), Steina's methodical construction of increasingly complex machine mechanisms contains elements of suspense and search for a resolution. Her integration of working method into the videotapes themselves allows the viewers to engage in her process of discovery.

For Woody, it is the artificiality of narrative—the way in which narrative structure is mapped onto human experience—that deserves exploration. His concept of narrative is highly ambivalent; he embraces an antinarrative strategy that is both seduced by and hostile to the traditional narrative form. As someone who grew up in Eastern Europe in the 1940s and 1950s, he sees narrative structure as inherently political, representing the voice of the state; it is linear and without nuance. He says:

> We all knew about how narratives are constructed and about symbolic language. In communism you must disguise everything in symbolic language so it is a fluid form of expression. I wanted to purge it. I came here to be free of it and that's why it's a continuous temptation I have with narrativity—I cannot accept or practice it.[6]

The Commission (1983) and *Art of Memory* have been heralded as Woody's entrance into narrativity, yet each can be seen as a highly ambivalent narrative text. In conceiving *The Commission* (pl. 13), Woody looked for, in his words, the most "banal story of the

39

nineteenth century, to pay tribute to the nineteenth century with an incoherent text, a kind of free treatment of real-time panels." He chose the "banal story" of a rivalry between two male art heroes, composers Niccolò Paganini and Hector Berlioz, to be played by two alter egos, artists Ernest Gusella and Robert Ashley.

The narrative and antinarrative strategies of *The Commission* are concerned with the tragic consequences of the various roles played by artists — the martyr; the starving genius; or the prima donna, dependent on patrons and government funding — and the corrupted aspects of art making. Yet, the central theme of *The Commission* is how specific electronic imaging techniques can be used to represent narrative. In the opening sequence, images burst forth from a central point on the screen to fill the frame in order to depict an image stream of Paganini's ramblings. As Paganini plays the violin, digital sampling is used to create a shadowing of his movements, so that their digitized traces evoke the energy of the music. When Paganini hands the commission to Berlioz, a flip-flop technique is employed, so that the videotape flips back and forth between two revolving images of Berlioz and Paganini circling each other, emphasizing the tension of the exchange. As Paganini's body is embalmed, the scan processor renders his corpse as a skeletal and eerie texture (fig. 3). The videotape can thus be seen as posing a number of questions: What does each analog or digital effect mean in narrative terms? How can it offer us an alternative to the codes of cinematic language — montage, the fade, the zoom, the cut? How can it deconstruct narrative? At the same time, this work is as much about the seductions of narrative as it is a project of antinarrative. It tells a compelling story, with the characters of Paganini and Berlioz often merging with those of their portrayers.

Since he identifies the strategies of montage and decoupage so heavily with cinematic narrative language, Woody's counter-strategy is to avoid any instance of cutting directly from one image to another. In both *The Commission* and *Art of Memory*, he structures images in forms that avoid the cut. In *Art of Memory*, this means

rendering the video image frame-unbound by turning it into a three-dimensional object that removes it from any reference to representations of reality. This is the image as object, an attempt to avoid the tendency of the camera image to fetishize and to counter dominant narrative form. Working with the scan processor and the Digital Image Articulator, Woody transforms newsreel footage and documentary photographs into unusual, almost organic shapes that stand out from the landscape as cinematic artifacts refusing to conform to electronic space. These image objects are strange and evocative, sometimes resembling large movie screens in the desert, other times awkward, bulky, and indecipherable shapes (fig. 4). As three-dimensional objects they radically decontextualize the images of history.

NARRATIVES OF MEMORY AND HISTORY

The different relationship of the electronic image to the photographic image's role of furnishing evidence is thus a central aspect of Woody's project. *Art of Memory* (pl. 15) reflects on how the construction of memory and history is mediated through the camera arts. It takes as its material the black-and-white photographic and film images of historic events of the first half of the twentieth century: the Spanish civil war, the Russian Revolution, World War II, and the atomic bomb. Woody establishes the process of history making as his central topic, but reorchestrates historical images in a jumble of objects and frames; this is a text of memory, fragmented and refusing simple coherence. Some images assert themselves, emerging to suggest narratives — such as Robert Oppenheimer's famous post-atomic bomb speech, in which he quotes the *Bhagavad-Gita* — but are then resubmerged in the flow of images and the rush of history.

Yet, within this dense layering of images, Woody does hint at a narrative. A mythical winged figure sits on a cliff. Seeing it from a distance, a man tries to capture its attention. He tosses a pebble at it, and then, when it turns toward him, he photographs it, causing

40

it to rise up and swoop down upon him. The creature is unexplained but it suggests many possible meanings. An unattainable mythic man/beast that the nervous and distracted middle-aged man, haunted by the images of history, tries to capture with his camera, as if he is trying to photograph the well-known "angel of history" described by Walter Benjamin:

> His face is turned toward the past. Where we perceive a chain of events, he sees one single catastrophe which keeps piling wreckage upon wreckage and hurls it in front of his feet. The angel would like to stay, awaken the dead, and make whole what has been smashed. But a storm is blowing from Paradise; it has caught in his wings with such violence that the angel can no longer close them. This storm irresistibly propels him into the future to which his back is turned, while the pile of debris before him grows skyward.[7]

FIGURE 3 Woody Vasulka
THE COMMISSION 1983
Video still

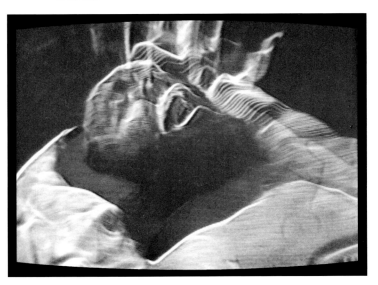

Benjamin wrote of the angel of history while witnessing the rise of fascism in the 1930s, and his words echo through the image forms and haunting voices of *Art of Memory* with its sense of history propelling forward. Woody's alter ego tries to capture the creature photographically, to hold it in place and prevent it from hurtling toward the future. Yet *Art of Memory* proves that the photographic image is ephemeral, its meaning shifting. The images of history lose their individual meaning and become a tangle of memories swallowed by the electronically rendered desert landscape. Voices echo these images; we cannot understand them, but we know, with their scratchy sound and intonation, that these are the voices of history.

The form of *Art of Memory* reveals not only the malleability of historical images but also of the different cultural meanings of film and video. Here, the image objects deny the possibility of finding a truth in historical artifacts. The incongruity of these images of history set against the dry forms of the American Southwest evokes a kind of timelessness; the desert landscape is emblematic of time marked within the earth, the past and the future merged. *Art of Memory* is thus an attempt to situate the images of history within the fluid terrain of time, to mark their ephemerality.

It is the camera image that provides us with cultural memory, yet it is a memory that shifts and changes, and is constantly reinvented and reenacted. The fragmented film images that form Woody's image objects and the static photographs of figures of history — from the anarchist Buenaventura Durruti of the Spanish civil war to the revolutionary Rosa Luxemburg — that scroll across the screen are processed until they are translucent, shredded as though by the passage of time. Hence, *Art of Memory* reflects not only on the memory of this history, but also on the final days of cinema.

MACHINES REMAPPING SPACE

The eulogy to the cinematic image in *Art of Memory* operates to finally contain the question of cinema for Woody. Since its completion in 1987, he has moved into a completely new arena of

41

investigation, beyond the question of the code and the meanings of the image object to a concern with machine systems and their capacity to reconfigure space. In this move from cinematic space (light, shadow, and projection) to video space (the waveform and the signal) to computer-generated space (mathematical coordinates and the virtual), Woody has undertaken a systematic project of mapping. His attempts to understand machine protocol — how machine systems speak and interact with each other — have also pushed his explorations of machine agency into new territory.

The computer is a more effective antinarrative tool for Woody than the camera. Ironically, his move to understand electronic

redefinitions of space and to be completely rid of narrative structure has allowed for other kinds of engagements with the past. The move toward machine systems is an investigation into the ancient sciences of navigation and calibration. In both *Theater of Hybrid Automata* (1990) and *The Brotherhood* (1994–96), the military applications of these sciences are primary subtexts of the act of mapping and the designation of territory. Both works pose another register of questions about the agency of the machine and the relationship of the electronic machine to the mechanical.

Theater of Hybrid Automata (pl. 5), which refers to Giulio Camillo's ancient Theater of Memory, consists of a computer-driven mechanism that calibrates and maps a space defined by several target screens. It uses the principles of dramatic presentation to examine the rules that define the intersections of physical and virtual space. The installation represents what Woody calls an "enlightened tool" that is "internally interactive." By calibrating the exhibition space according to the placement of several "targets," one of which represents an imaginary north point, the device operates in two modes: "pointer" mode, in which the system indicates prescribed locations, and "locator" mode, in which the sensors scan the space and report on coordinates. In its mix of technologies, robotics, calibration, and forms of navigation, *Theater of Hybrid Automata* is about contextualizing virtual space in the history of measurement and mapping, but it is ultimately about the impossibility of mapping in that the space remains to a certain extent elusive and distinct from its calibrated models. It is, in Woody's words, a "confrontation" between a physical space and its synthetic representation.

Theater of Hybrid Automata thus poses particular questions about both the location and the agency of the viewer. It demands engagement from the viewer, but it does so in order to demonstrate that it can render the human presence superfluous. It plays off traditional notions of Cartesian space and the laws of perspective while situating the viewer, yet continues to

map by itself. Through its self-orientation, the machine thus acquires "memory." This work can be seen as an engagement with the question of memory in virtual space—Camillo's Theater of Memory was about mapping the cosmos and containing memory—as well as the implications of man's urge to map, calibrate, and navigate.

While issues of masculinity and mapping space underlie much of the *Theater of Hybrid Automata*, with its inferences of military science and the marking of territory, it is in *The Brotherhood* (pl. 7) that Woody allows the subtext of gender identity to fully emerge. In this work, the "brotherhood" is established through the tools of military hardware, which represent the alliance of technological devices to the service of war. This is not a moralistic or antimasculine move; rather, as Woody puts it, the work examines the "dilemma of male identity" that arises from the "general compulsion of mankind to reorganize nature itself." He adds, "This work does not argue for a reformist agenda or a strategy of defense. It stands sympathetically on the side of the male but it cannot resist an ironic glance at his clearly self-destructive destiny." [8]

In the series of table installations of *The Brotherhood*, Woody again returns to the mechanical in order to investigate the virtual, continuing his project of grounding new technologies in the phenomenologies and histories of previous ones. The tables integrate scraps of industrial and military waste—tables from junkyards in Los Alamos and elsewhere, an intercept table for war games, a writing instrument—with new systems technologies such as computer systems and three-dimensional images. In a sense, Woody comes full circle in *The Brotherhood* to unite the junkyards of the post-World War II culture of his youth with his vision of the ways in which electronic technologies can reconstitute the meanings of time and space.

The tables of *The Brotherhood*, with their automated parts, moving mechanisms, image screens of war, and insistence on viewer interaction, are also about exposing the narrative of artificial intelligence. On the one hand, Woody is lovingly crafting machines that intrigue, demand, and perform; on the other hand, he is actively working against a simple notion of machine intelligence, whether it be the concept of a "smart" weapon or a "thinking" computer. Yet, these tables are also exquisite tributes to the intricacies of the machine itself, in the pleasures of their mechanisms, and in their bridging of the optical, the electronic, and the mechanical.

STEINA: FROM THE INSTRUMENT TO THE MACHINE
Both of the Vasulkas have explored the capacity of electronic technologies to remap space; while for Woody this has been a project of mapping virtual and cartographic space, for Steina this has meant a concern with the viewer's phenomenological relationship to the landscape and natural processes. Indeed, one could say that while Woody has investigated the mapping of virtual and physical "indoor" space, Steina has mapped "outdoor" space—sky and landscape. Whereas Woody has explored the history of human catastrophe, war, and upheaval as contained in the camera image, for Steina history is inscribed not in fragments of archival footage but within nature; it is not the history of mankind, but the history of geological process, of fire, water, and earth.

While Woody has moved toward the question of the machine as an instrument, this was Steina's point of departure. Her conceptualization of the machine takes place through a physical engagement with the camera-instrument. Yet, like Woody, she has been intrigued by the possibility of an autonomous machine. She states:

> Having been an instrumentalist in music, I regarded the camera as an instrument from the beginning.... From my own camerawork, I saw that you are subjected to a very heavy editorial view. I started very early to think about how much better it would be if the camera image was not subjected to one person's vision. [9]

43

The 1970–75 videotape *Violin Power* (pl. 9) demonstrates Steina's replacement of the violin with the video camera. This work, which begins with a straightforward image of Steina playing a violin, represents an increasingly complex relationship of sound and image. Steina rigs her violin to imaging devices so that the music not only transposes the image of her playing the violin but actually generates it—the movement of the bow across the strings causes the image to erupt into a tangle of raster lines. She later examined the relationship of electronic sound and image in collaboration with singer Joan La Barbara in several works, including *Voice Windows* (1986), in which La Barbara's voice creates a visual interplay of a musical scale on a moving landscape. These works are, in essence, video compositions, in which the video image is both a visual realization of the musical form and an instigator of it.

In the mid-1970s, Steina began working on a project called "Machine Vision," a group of videotapes and installations concerned with finding a camera view that moved beyond the idiosyncrasies and restrictions of the human eye (fig. 5). Machine Vision is a project of dual purpose: to explore the question of machine autonomy and to attempt to realize a world view beyond limited human vision. One of the first Machine Vision works, *Allvision* (1976) consists of two live rotating cameras facing a mirrored sphere that reconfigures

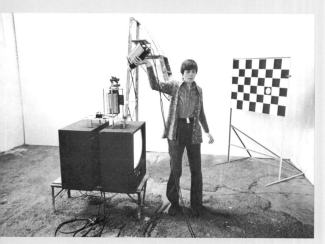

FIGURE 5 Steina working on the Machine Vision project
Buffalo, New York 1976

the surrounding space so that the viewer's position within it is entirely mediated by the machine. Through the reflective sphere, the cameras scan the space and remap it. The image of the viewer entering the installation is thus transposed via the mirrored sphere into the abstract virtual space of the video monitors. *Allvision* redefines space so that concepts such as inner/outer, left/right, forward/backward, and up/down have no meaning. Steina states:

> The cameras alone scan the whole room. The idea was of course that the whole room can never be perceived or understood by human vision. Inserting the sphere in between emphasized the absurdity. When I mount the camera on the car, I define it as machine vision, but when I use the sphere, it is the concept of allvision.[10]

Steina attempts to strip the camera of intentionality and to detach it from human intervention, while at the same time knowing the impossibility of this task. She presents it as a kind of half-joke in which the viewer is always complicit.

Throughout the 1970s, Steina explored Machine Vision in many works in which she orchestrated increasingly complex machine setups. First, she rotated a camera on a turntable, then added another camera and placed two cameras watching themselves on rotating monitors. She gradually began to use mirrors, spheres, and other optical devices. The result was essentially a reenactment and redefinition of the actual codes of cinematic movement: the pan, the tilt, and the zoom. In reinventing these codes and representing them within a mechanical framework, Steina attempts to strip her video work of its relationship to cinematic language. She presents instead a self-reflexive camera vision in which the movement of the camera is divorced from the narrative meaning assigned to cinematic codes.

The videotapes of Machine Vision include *Signifying Nothing*,

Sound and Fury (1975), *Switch! Monitor! Drift!*, *Snowed Tapes* (1977) (which are compiled in the later work *Orbital Obsessions*), and *Urban Episodes* (1980). Each of these process videotapes represents a journey in which Steina is both actor and director, revealing her conceptual explorations by demonstrating in real time her step-by-step complications of camera machines. The viewer is thus privy not only to her thought process but also to her phenomenological interaction with electronic space. Steina sets up cameras facing each other and then uses a flip-flop switcher to alternate their images; she places herself within the frame, almost appearing to peek in and out to see how the machines are reconstituting her image. She uses her body as a mediating force, as if it were a found object though which machine capabilities can be charted. Steina's movement within her camera mechanisms creates a tangible presence—the mechanical within the electronic and the body within the camera space.

In later works, such as *Summer Salt* of 1982 (pl. 12), with its sections *Sky High*, *Low Ride*, *Somersault*, *Rest*, and *Photographic Memory*, the exploration of the mechanical and the body within electronic space is mediated through a lens attachment that mimics the effect of the mirrored sphere. Images are transposed out of the standard rectangular frame—horizons become circles and simple landscapes appear to form microcosms of the world, orbiting within the frame. Each section of *Summer Salt* contains a different camera-defined viewpoint. In *Sky High*, Steina attaches a camera with a mirrored lens on the roof of a moving car, turning a highway into a global rush of images. In *Low Ride*, she drives with the camera on her bumper through a field of grass, an effect that creates tension through both its irreverence for the camera's safety, and the tactile audio/visual impression of grass loudly thumping against the microphone. The humor of *Low Ride* is echoed in *Somersault*, in which Steina performs gymnastics with her camera with the mirrored lens attachment, swinging it through her legs, bumping it with her hips, and creating a globalized circular impression of her

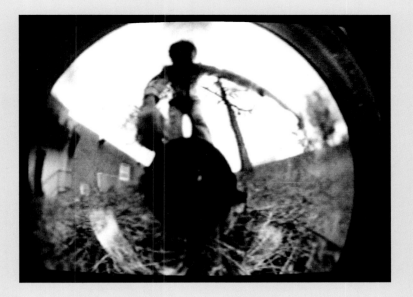

FIGURE 6 Steina
SUMMER SALT 1982
Video still

torso (fig. 6). In decentering the viewer's sense of gravity and inserting her body as an active force within the frame, Steina is creating a physicality with the camera, which provides a means to choreograph a space defined by the interaction of body and camera. One's lasting impression of *Summer Salt*, however, is one of irreverence and humor. Steina seems to be saying that the camera is a playful object that can comically demonstrate new perspectives—the view of a car bumper, the vision from a gymnast's props. The pleasure in this work is precisely in its refusal to be serious.

MARKING LANDSCAPE

Perhaps because of her background as a musician, Steina has a tendency to treat content ambivalently; space is her subject matter. Whether that space is her studio or the landscape of the Southwest is initially unimportant to her; what matters is how it

45

can be reconfigured in video. After the Vasulkas moved to New Mexico in 1980, Steina began to work with the Southwestern landscape. While landscape can now be seen as a central theme in her work, she does not actively situate her work in the tradition of its visual representation in art. She is primarily concerned with how different geographies can be reconfigured through her machine mechanisms. She says:

> I moved here because I wanted to experience what it is to live in beauty. I did not want to think that it was going to affect my images as much as it did. For the first two years I resisted it. First of all because the beauty of the West is so seductive. And, secondly, I didn't feel up to it. I mean, are you going to take on God? I had always had large interiors in which to work, and suddenly we were restricted to a small house. I just went outside one morning and said, "Well, my studio doesn't have any walls and the ceiling is very high, and it's blue." I just adopted the whole Southwest as my studio. So that's when I made my peace with the idea that the landscape of the Southwest was going to be my image material.[11]

The exercise of placing her body and camera outdoors in *Summer Salt* moved into a more conscious engagement with the Southwestern landscape in the 1983 installation *The West* (pl. 4). In this work, Steina examines the relationship of landscape to time, in particular the way in which the desert symbolizes both geological time and human imprints on the land. The dry conditions that preserve evidence of ancient civilizations are also responsible for the presence in New Mexico of various scientific enterprises, including the Very Large Array (VLA) radio telescope systems, a line of huge satellite dishes listening in the desert. Thus, the Southwestern landscape represents technological change and acts as a symbolic indicator of the progression from the human mapping of the land to the mapping of space.

Steina puts the stationary landscape of the Southwest into movement in *The West*. Working with horizontal drift, she orchestrates two channels of video so that two constantly sliding and overlapping images give the impression of the video frame being in constant motion. In the circular shape of the mirrored sphere, the desert landscape takes on global proportions, spinning and revolving, with no horizon; Native American ruins appear overlaid with space-age telescopes. Simple concepts of the land are thwarted. Indeed, *The West* is a work that borders on a romantic vision of the landscape, only to pull back and juxtapose the incongruous.

Refiguring the Elements

The landscapes that are charted through *The West* are strikingly immobile; they are only set into motion through the carefully choreographed motion of Steina's devices. However, the movement of nature has been a constant theme in her work. In *Flux* (1977) she examines the phenomenology of running water, creating a sensual and aesthetic engagement with its quality of motion. Using a flip-flop technique to switch rapidly between two images of rushing water, she creates a tension of expected movement. Then the images are transposed by the scan processor to create an electronic waveform that echoes the physicality of the water. The movement of nature is thus juxtaposed with the corresponding motion of the electronic waveform.

One can easily read in works like *Flux*, *Geomania* (1989), and *Borealis* (1993) the pleasure that Steina takes in deconstructing the movement of nature. Indeed, it is as if Steina has used the medium of video to effectively reorchestrate the geological processes so evident in the shifting terrain of her native Iceland. The use of analog and digital imaging as both geology and geography compels her later work. In the installation *Geomania*, she uses video to ironically combine the volcanic and oceanic scapes of Iceland with the dry desert of the Southwest—waves wash over the desert and volcanic gases bubble up through rocky terrain.

Thus, video techniques take on the metaphoric role of merging the landscapes of Steina's various homes — the arid and still desert with the fluid, churning, mutable terrain of a volcanic island. For Steina, the earth can be reconstructed through video in defiance of its materiality.

In Borealis (pl. 6), a dark room with suspended video projection screens encompasses the viewer in the visceral interplay of natural processes. Water is electronically reorchestrated through direction reversals, layering, and flip-flopping. This is not the stationary landscape of *The West* but rather nature pushing at the screen, rushing at the viewer. On the large screens, the water is oversized and dizzying. Steina then takes her camera into the rough terrain, bumping it into frozen plants and thumping and scratching the earth's surface. This is a heightened sense of water and land, up close and in your face. *Borealis* is about getting as close as possible to the constant movement and fluidity of nature, which is seen as powerful and unstable. The darkened room and projection screens force the viewer to step into the moving image and its audio/visual textures. *Borealis* thus circles back to *Allvision* in its desire to decenter viewers and set them in motion.

In the 1987 videotape *Lilith* (pl. 16), Steina continues this concept of integrating the body into the landscape in a more literal fashion. She renders Doris Cross into a hybrid of human and nature. Cross's face is integrated into a forest-like tableau through analog processes, giving her a primordial and eerie presence. Lilith is the mythical first wife of Adam, and Cross embodies, through her slowed voice and craggy features, a strange figure of mystery. Yet, there is nothing particularly mystical about this transposition. Cross's face is as much a tribute to an aged and well-worn face as it is a study of the deteriorating human corpse reintegrating into the earth.

In all of Steina's landscape work, the view of the earth is both of awe and irreverence; on one hand paying homage to the aesthetics of nature, on the other deliberately reconstructing it into new, "improved" forms. One has the sense that Steina is rechoreographing the earth. Yet, at the same time, she is clearly resisting simple clichés about nature and its meanings. The humor in her work and its disdain for simple concepts of beauty prevents it from fulfilling any essentialist concept of woman and nature. Indeed, one could say that Steina is countering any reverence for nature with a technological retort of "what if?" What if waves could wash through the desert? What if water ran backwards? What if we could stop it all in a frame?

In the 1989 videotape *In the Land of the Elevator Girls* (pl. 17) and the 1991 installation *Tokyo Four* , this refiguring of space is transposed to the terrain of Tokyo, where she creates visual motifs to enact her role as an outsider peering in. It is testimony to Steina's indifference to subject matter that she can take an urban setting and treat it as a landscape. She uses horizontal drift to create a motif of opening and closing — a proscenium that lets foreigners in, but then shuts them out again. The framing device is the constantly moving elevator doors of Tokyo department stores, accompanied by the elevator girls whose job it is to greet shoppers and usher them in and out. The elevator doors, recreated in digital effects with horizontal drift, open onto scenes of Japanese life: Shinto priests sweeping their gardens, train conductors at rush hour, a volcanic landscape, a virtual reality demonstration, the choreographed movements of a dance troupe. In this work, horizontal drift is deployed as a metaphor for the observations of the visitor to Japanese culture, glimpsing particular moments and experiencing the layered impressions of the rhythms of daily life. The elevator doors are both an entryway and a barrier that closes on the viewer's desire to see into the rituals of the city.

Within all of Steina's work, a series of questions is thus posed: What does it mean to reconfigure space, to reorchestrate landscape, or to remap nature? What does it mean to change the viewer's relationship to space? From the redefinition of space in

47

Allvision, which situates the viewer in between physical and electronic space, to the remappings of nature in *The West* and *Borealis*, to the depiction of cultural voyeurism in the closing doors of *In the Land of the Elevator Girls,* Steina forces the viewer's body into the work. Here, there is no central point of perspectival vision, no center from which the viewer posits his or her self, but rather a construction of space in which the viewer floats in the rotating spheres of landscape and studio space, ever in motion, never static. The viewer's position in Steina's work is defined not by physical space and geometry, but from within an electronic space—of transmission and reception, in which geographies are malleable and the physical can be transgressed. Its meaning is precisely in demonstrating the intangible of physical space and the natural world.

MACHINE MEDIA

A journey through the Vasulkas' work is thus a journey through the history of the machine and an investigation into the importance of the past in the present and the historical machine in the technologies of the future. Their work defies simple narratives of technological progress, precisely because of the ways in which it situates new media within their technological legacies. For the Vasulkas, the machine is both a creature of autonomy and a source of possibilities. From the elemental nature of the Digital Image Articulator to the bulky machine images of *Art of Memory* and the contained arbitrariness of the machines of *Theater of Hybrid Automata* and *The Brotherhood*, from the mirrored mechanical Machine Vision device of *The West* to the projected world of *Borealis*, the Vasulkas have created several generations of machines that defy simple notions of agency and programming. These machines dramatically pose questions about authorship as the Vasulkas consistently attempt to award them autonomy and to speak their language. These are machines that command our attention and demand a dialogue.

Notes

1. Woody Vasulka, in the videotape *Artifacts* (1980).

2. See the catalogue for the show, organized by the Vasulkas, *Eigenwelt der Apparate-Welt: Pioneers of Electronic Art,* ed. David Dunn (Linz, Austria: Ars Electronica, 1992); and Martha Rosler, "Video: Shedding the Utopian Moment," and Marita Sturken, "Paradox in the Evolution of an Art Form: Great Expectations and the Making of a History," in *Illuminating Video: An Essential Guide to Video Art,* eds. Doug Hall and Sally Jo Fifer (New York: Aperture, 1991).

3. Woody Vasulka, interview with Gene Youngblood and Peter Wiebel, Santa Fe, New Mexico, October 12, 1986.

4. Ibid.

5. See Lucinda Furlong, "Notes Toward a History of Image-Processed Video: Steina and Woody Vasulka," *Afterimage* 11, no. 5 (December 1983): 15.

6. Woody Vasulka, interview with Marita Sturken and JoAnn Hanley, Santa Fe, New Mexico, July 24, 1987. Unless otherwise noted, all subsequent quotes are from this interview.

7. Walter Benjamin, "Theses on the Philosophy of History," in *Illuminations* (New York: Schocken Books, 1969): 257–58.

8. Woody Vasulka, artist's statement, 1994.

9. Quoted in "Studios," *Steina & Woody Vasulka: Vidéastes 1969–1984: 15 Années d'Images Electroniques,* ed. Dominique Willoughby (Paris: Ciné-MBXA/Cinédoc, 1984).

10. Steina, artist's statement, 1976.

11. Steina, interview with MaLin Wilson in the exhibition brochure *Scapes of Paradoxy: The Southwest and Iceland* (Albuquerque: Jonson Gallery, University of New Mexico, 1986).

Reading the Tools, Writing the Image

MAUREEN TURIM AND SCOTT NYGREN

During the 1970s, Steina and Woody Vasulka helped shape the parameters of video art. They founded The Kitchen as an intermedia exhibition space, contextualized video in relation to electronic music and performance art, and played a leading role in the development of synthesized video. These innovations placed the Vasulkas among those who seem to have created video as a field by pioneering its institutions and orienting its projects.

Like other innovative practices that emerge at a break between established and new media, their work is marked by the rhetoric of the period. Yet their ideas, installations, and videotapes speak in important ways to contemporary concerns of art and technology. Decades ago, the Vasulkas moved into an electronic environment that the general public has begun to inhabit only recently with the mass marketing of interactive multimedia computers. An exhibition of their work invites a reconsideration of the historical juncture that marks their entrance into this electronic landscape. It allows us to speculate about underlying theoretical formations in their installations and videotapes, helping us to anticipate and understand long-term cultural change.

Even the most recent work included in this exhibit derives its energy from principles implicit in some of the Vasulkas' earliest videotapes, as initial traces of generative principles now reaching a much fuller realization and recognizability. The visual intensities of *Lilith* (1987), the logical architecture underlying *Theater of Hybrid Automata* (1990) and *The Brotherhood* (1994–96), and the electronic landscapes of *Borealis* (1993) all reconfigure operating principles initially worked through in such earlier videotapes as *Noisefields* (1974), *Digital Images* (1979) and *Land of Timoteus* (1977). The genealogical recognition of those earlier pieces through their traces in current work can operate as a kind of anamnesis, as Jean-François Lyotard uses the term, a deliberate "not forgetting" of the processes of innovation and cultural history.[1]

The Vasulkas' video was conceived in the context of a late 1960s rhetoric that celebrated involvement and exploration. Individual videotapes were not valued intrinsically as commodities or objects, but emerged as the by-product of a largely intangible generative process. Recordings were imagined as supplemental, analogous to the notes of physicists or anthropologists exploring

49

an unknown domain. The central invisible concern remained the exploration of the electronic field, unavoidably absent to the viewer of videotapes. The 1960s rhetoric of process helped bypass critical methods of formalist analysis and authorial style still strong at that historical moment, particularly among the art critics and curators who were beginning to address video. It functioned to legitimize apparently inconsistent styles, enabling the shifts from abstraction and logical systems to camera realism and expression that have characterized the Vasulkas' work.

These rhetorical strategies functioned to suggest an early orientation for the still amorphous field of video. However, as so often happens, the working concepts that facilitate the production of new work may unintentionally foreclose a theoretically informed rereading. Given the context of the 1960s, the appeal to process inevitably reinscribed a mythology of "presence" at the center of the Vasulkas' artistic project, one derived from the phenomenological privileging of experience. This might now be better understood in terms of the unrepresentable at the basis of all possible representation. In retrospect, the videotapes as dynamic texts embody several concerns that are only partially articulated by the rhetoric of presence and process that originally worked to legitimate them. Accordingly, current media and cultural theory can provide an alternative access to the Vasulkas' work, in place of the often mythologized notion of artists at the electronic frontier.

WRITING THE IMAGE

In part, the Vasulkas' work seems to continue the modernist project of questioning illusionistic representation. Much of their work substitutes abstract pattern for an unexamined experience of camera imagery as live, unmediated presence. Jacques Derrida argues that the desire for "presence" is a central myth of Western civilization. By presence, he means seeing specific meanings as fully and naturally inherent in representation, so that cultural meaning appears as self-evident truth. If Western culture can be

characterized in this way, then these metaphysical assumptions reach a peak of development in the technology of "live" television. "Live" camera illusionism perpetuates nineteenth-century assumptions about perception as a passive, direct, and unproblematic receiving process. These assumptions in turn operate to embed ideology and desire in the appearance of the "natural." In contrast, images generated entirely by video synthesizers do not appear natural. Even camera images that are processed by synthesizers depart from traditional concepts of realist or expressive representation. Both move closer to theoretical concepts of moving imagery as a mode of writing. An interest in imagery as writing is already suggested by the title of the Vasulkas' early work, *Calligrams* (1970), which refers to Guillaume Apollinaire's poems that reshaped printed texts into images.

The idea of camera imagery as writing is one of the oldest concepts of mechanical reproduction, embedded in the terms "photography" and "cinematography," both neologisms derived from Greek words for writing with light and with motion. Yet these have been displaced by the terms "television" and "video," which mean literally "seeing at a distance" and "I see," a direct equation of perception and technology as complete simulacrum. This equation is based on unconscious cultural assumptions that have not yet been problematized by such modernist strategies as reflexivity, so that premodernist habits of thought often re-emerge in practice even when theoretical premises to the contrary are well known. In part, the Vasulkas' projects interrogate such unconscious habits: in works such as *Soundgated Images* (1974) and *Time/Energy Objects* (1975), the Vasulkas have seemed to insist on an analytic understanding of the electronic signal or waveform as a model for visual representation. *Soundgated Images* uses the signal from the soundtrack to control the image, so that the viewer is invited to imagine the electronic waveform that unites both. *Time/Energy Objects* displays abstract forms in which the viewer can visually identify

oscillator-generated sine, triangle, and square waves as constructive elements (fig. 7).[2] As such the signal becomes both the substance that enables writing and the evidence that such writing has occurred.

Yet the Vasulkas' use of abstraction always alternates with, or is tied to, a return to camera imagery. Conceiving of abstract oscillator-generated images in terms of late modernist aesthetics, such as articulating the pure characteristic features of the video medium, is an approach now taken for granted. The camera image returns in a different context, precisely because it is known and seen to be a signifying construct; hence, the camera becomes one means among many to generate an image. A videotape like *Time/Energy Objects* not only visualizes the signal, but also plays with the constructed illusion of three-dimensional objects on the flat video raster. The blank, white screen of video's 525-line display is magnetically reshaped by the scan processor into simple geometrical forms.[3] The minimalist aesthetics of the objects so represented are tied to 1960s concerns in painting, music, and the performing arts, but the new interest in how an illusionistic image can be seen in itself as constructed shifts the videotape's stance into the postmodernist 1970s. The camera image in the context of the Vasulkas' abstract work becomes one more means of generating objects through signal manipulation. Even the sensuous landscapes of the 1983 work *The West* (pl. 4) set the camera image against a subtle but vivid use of synthesized color unique to video.

At the same time, the Vasulkas' continual return to camera images plays against the contemporary commercial use of computer effects in a different way. Mass culture tends to use high-tech imagery to assert self-evident meaning today in the same way that classic Hollywood used photographic realism. The Vasulkas sidestep this succession of dominant styles by continually opposing realistic and synthesized imagery. If pure abstraction never becomes completely central to the Vasulkas' work, neither does camera illusionism ever appear quite enough. The play between

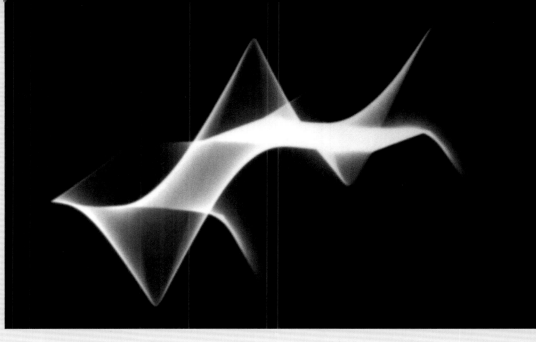

FIGURE 7 Woody Vasulka
TIME/ENERGY OBJECTS 1975
Video still of scan processor effects

the two, together with the disjunctive values they represent, replaces a hierarchical valorization of either modernist abstraction or classical illusionist styles.

Further, this tends to be true whether Steina or Woody is credited for a particular work. Part of the narrative that surrounds the Vasulkas' long-standing collaboration is that Woody moves toward the abstract while Steina returns to the concrete. Woody will become a purist at a certain point, insisting on only processed imagery as in *C-Trend* (1974), while Steina will return to easily recognizable camera imagery as in *From Cheektowaga to Tonawanda* (1975). Yet both these videotapes involve processed imagery that fuses camera material with abstraction, and the difference between their aesthetics might be better characterized as parallel principles in different domains. However, this is also problematic, since Woody embraces camera imagery in his later narrative work, and

51

they collaborated on the purely abstract *Noisefields*. It is perhaps more appropriate to abandon any and all easy polarizations of their aesthetics in order to recognize shared operational principles and complex, as well as distinctive, aesthetics.

Reading the Tools

One of the established tropes of the Vasulkas' work has been the notion of tool exploration. They have both tried out new tools (e.g., digital imaging devices beginning in the mid-1970s) and redis-covered old ones (e.g., introducing a deliberate horizontal drift into cameras long capable of such activity, but from which such drift was conceptually excluded in the design). In both cases, they sought effects not yet discovered or fully developed. Yet in retro-spect, the immediately apparent effect of novelty and innovative visual design is insufficient to explain the powerful and lasting effects of these works. There is a different kind of determining fig-ure, in the sense of a generative trope within visual discourse, simultaneously embedded in this project. The underlying assump-tion in this artistic project is that tools are not self-evident in their use or in their internal organization, and that they require an activity not unlike that of reading. Tools themselves in the Vasulkas' work *become texts*, with an internal logic that is far from unproblematic.

Much of the Vasulkas' use of tools seems driven by an inter-est in the discrepancies between different levels of organization within the machine. These discrepancies are normally concealed in commercial television production, which prescribes a central aesthetic of camera illusionism to unify otherwise disparate styles. All anti-illusionist aspects of electronic imaging in con-ventional television are relegated to the domain of technical problems or to transitions between programs. The tools them-selves are manufactured to automate this ideological demand for illusionist effect and to efface all internal contradictions. The Vasulkas reverse tool organization from this automated set of

conventions to an open-ended multiplicity of possibility and pur-pose. For example, *Evolution* (1970) marks their first use of deliberately induced horizontal drift as a compositional strat-egy, while *Digital Images* investigates the capacities of digital synthesis to control the individual pixels that form a video image.[4] In these videotapes and others like them, the implica-tion is that such image-generating capacities are internal to the machine and contradict camera norms.

Woody's *Theater of Hybrid Automata* (pl. 5) updates and recon-figures tool reading as a parodic deconstruction of Western representation, now epitomized by virtual reality (VR) technolo-gies. This installation incorporates images that oscillate between camera illusionism and computer-processed abstraction, reestab-lishing the conflicting principles of camera and signal. A machine-controlled camera rotates and revolves among five visual targets, foregrounding computer interactivity and robotic control as an aspect of the tools that now need to be read. By so doing, *Theater of Hybrid Automata* turns conventional ideas of VR as an immersive realist landscape inside out, revealing its unconscious assumptions. As machine, VR constructs its images through an electronic signal, and as cultural representation it embodies the hierarchical grid of illusionistic perspective as if identical to nature. Woody's installation inverts these assumptions by fore-grounding the signal construction and perspectival grid repressed by VR's hyperrealism.

Theater of Hybrid Automata's five screens are placed to indicate the six compass points of a surrounding three-dimensional envi-ronment, like the the x-y-z axes of a Cartesian grid. Cartesian space is, of course, the organizing principle of illusionistic perspective that makes Western ideas of landscape possible. The x-y-z axes that formed the basis of signal investigation in *Time/Energy Objects* have now become an installation environment, placing the viewer within the conceptual framework that generates the video camera's mass production of realist space. *Theater of Hybrid Automata*

suggests the controlled contact with reality implicit in VR's demand for a completely immersive space, together with a critique of how reductive such a conception of the real turns out to be.

The hybridity of the automata in this theater is accordingly multiple. Although based on the interaction of human and machine, the installation shifts our attention to the hybridities of writing and imagery, and of machines and cultural representations, which are constituted autonomously prior to the participation of a viewer. The viewer then enters into a double position in relation to the hybrid automata that surrounds him or her, which operates both as a playful deployment of alternative symbolic systems and a parodic critique of the prisonhouse of representation implied by realist preconceptions of VR.

Throughout the Vasulkas' work, machines as texts can be read in terms of their plural constitutive elements, from signal pattern and raster design to horizontal stabilization, pixel units, and digital control. In their more recent work, technologies and their codes are increasingly linked to cultural history. In the Vasulkas' reading, each element can be deconstructed to generate distinctive compositional possibilities not predictable by conventional practice, as a fertile resource for artistic interventions. Both videotapes and installations in a sense become printouts that allow us to read the machines that generate them, as well as the cultural assumptions these machines embody. From this position, machine logic can be rethought.

Rethinking Machine Logic

The Vasulkas have often referred to the underlying code by which images are constructed or inscribed on the monitor surface. Woody, for example, has said, "You have to master the code.... The code should be controlled and finally specified by creative people, artists."[5] We might generalize this interest in the code or electronic signal to other parallel processes of depersonalizing, mechanizing, or programming image production in order to reconfigure the boundary between the personal and the machine. This area of concern might also include the Vasulka practice whereby one person "sets up" a system (i.e., programs it) and the other runs or uses it.

Their commitment to "real time" image synthesis, as in *Digital Images,* fits this project, despite the apparent paradox of a seemingly realist impulse that leads to effects quite alien to realism. The commitment to "real time" limits computer processing to the programming of moving imagery, rather than reconstructing motion through slowed computer generation of separate video frames (or fields).

Woody: [I]f you involve the computer, the picture must be disassembled and assembled again, point by point, number by number, and this can take a much longer time than necessary to represent a moving image. So we say if a system cannot process or originate pictures as continuously moving, we lose *real time*. When we lose the illusion of continuous movement, we lose *real time*.

Steina: It's the most important thing . . . I would sacrifice any kind of image resolution, any kind of perfect image, rather than sacrifice *real time*.[6]

By "real time," the Vasulkas are insisting that the computer be fully "interactive," as that term has come to be known or imagined through the marketing of multimedia computers. Computers in the 1990s promise a dynamic intimacy of machine-human cooperation that so far continues to exceed the practical limits of consumer technology, but the Vasulkas began to insist on such interactivity as an operational premise decades ago.

For the Vasulkas, the choice has often been to sacrifice image resolution or detail rather than movement in order to keep the image dynamic and interactive.[7] The crucial factor here is the simultaneity of processing and recording that allows the entire

53

process to remain visible and avoids any post-production reassembly of material. Movement is the guarantor of this simultaneity, but realism is not the goal. The commitment to "real time" is not an appeal to an imaginary truth of presence inherent in realism, nor even to interactivity in any naturalistic sense. It is something quite different. "Real time" insists on locating writing within the image, within moving figuration as experienced through time. The illusion of movement allows the videotapes to indicate how video is a "writing apparatus" creating the illusions that are operative in representation.

Video practice can in this way be reoriented away from a metaphysics of pure presence in a way that other types of video programming cannot. Commercial computer image programming is conceived as subserviant to an illusionistic presence, so that we are invited to imagine computer production as something that happens before and outside of the images we watch, without leaving any apparent traces except as illusionistic magic. Programming in so-called "real time" insists that the process of image production cannot be so hierarchized, with programming or writing subordinate to an illusion of unmediated perception. Implicitly, it argues that writing or programming is internal to perceptual and cognitive experience. At the same time, the Vasulkas' work cannot be conceived simply in terms of a modernist foregrounding of technique or reflexivity of the art object. Signifying practice in their work becomes instead a continual and simultaneous play of perceptual experience and representational construction, of presence and absence, not a subordination of one to the other.

PERCEPTUAL-COGNITIVE CYCLES

The Vasulkas' longstanding interest in neurophysiological experimentation concerning visual perception is one indication that we need to consider how their videotapes engage the perceptual and cognitive processes of the viewer. Their formal experimentation with the specific properties of the video image raises the issue of how the viewer is engaged by these properties in new and challenging ways.

Scientists now believe that we do not receive images as entities projected onto our consciousness, as assumed in earlier models of perception that posited a retinal image transmitted periodically as a whole picture. Painting, photography, and even film images offered analogues for this earlier model of perception. Their images seemed to present themselves to the eye as framed pictures, ready to be inverted as projections on the retina. Film projection "mirrored" this process in its projection of the image onto a screen.

Rather than assuming a matrix of perception that is comprehended only once it is received in full, contemporary cognitive theories of perception conceive of sensory and brain processes as entirely intertwined. In other words, no perception occurs prior to cognition, a concept introduced in the 1960s by Ulric Neisser as a perceptual-cognitive cycle.[8] More than prior modes of visual representation, the video apparatus offers a model for such interactive circuitry. Video's internal temporal construction as a field of phosphors shifting at a rate of sixty cycles per second (cps) offers a more dynamic correlate to the retina's own cycles of diverse transmissions. Though television was designed to mimic conventional uses of the filmic apparatus, video has the capacity (already developed in experimental film work) to dissect and deconstruct the framed entity of the image.

Noisefields, in an implied comparison to the perceptual play of Op art and the "flicker" film, examines video flicker (fig. 8).[9] Solid color fields and snow flicker in alternation (at the field rate of sixty cps), within a space defined by a circular mask. Though individual frames only have simple patterns, the videotape as it is perceived in its temporal unfolding generates more complex "illusions." Video flicker is more complex than film flicker, since even the "frame" is assembled in the viewer's mind and is never

physically present on screen in its entirety. The video screen's phosphors are illuminated for only a fraction of the time that each field or frame demands, so that complete "frames" are displayed only through automated VCR features or within the perceptual-cognitive system. If perceptual "illusions" are stimulated by *Noisefields,* they suggest the reciprocal illusion by which we imagine that a video "frame" exists as a unified entity like that of film.

Whereas flicker in video is usually concealed as much as possible within the flow of a representational illusionism, just as it is in film, in *Noisefields* it is manifest as a phenomenon that undermines and illuminates the threshold of our perception of discrete units, while simultaneously highlighting the role of mental processes in perceiving stimuli as "images." The perceptual field is never simply an external object that we sense, but a creation of our mental activity as we participate in perception. The shimmering quality of video snow gives *Noisefields* properties different from its filmic counterparts; the closer equivalent might be the pointillist Op art works (although the "movement" of the dots in Op art is entirely illusory, while in video the pixels do change). One can imagine an animated film that would blend the graphic qualities of the artwork with temporality and actual change. *Noisefields* is just such a hybrid, suggesting that video itself will come into its own through an understanding of its hybrid heritage. In reconceiving flicker as videographic, the videotape acknowledges its closeness to perceptual experimentation in film, while marking video's difference (spatially and temporally) as another sort of image.

Similarly, in *Land of Timoteus* Steina borrows principles of single-screen, three-dimensional effects from the work of Alfons Schilling, a New York artist with whom the Vasulkas collaborated. Like Schilling's 3-D slide presentations, this videotape creates the illusion of three-dimensional space by temporally alternating slightly displaced fields of vision. In Steina's piece, the representational material is a panning shot of an Icelandic landscape, in which jutting foreground rocks are sharply distinguished from the background space. The scene is rendered as a three-dimensional image by switching back and forth between two spatially displaced shots at a rate of approximately six times a second to create the illusion of spatial depth. Cognitively the viewer receives somewhat the "same picture" as unmediated binocular vision, but the rules of this game are not simply the thrill-seeking, stylized realism of a 3-D movie. Rather, the perception of depth itself is examined as a lesson in the relativity of space, time, repetition, and displacement within cognition. At the site of maximal perceptual immediacy, the landscape of one's homeland, the apparatus paradoxically fails to reproduce a reality. Instead, it intervenes to subtly dislocate the viewer from the space presented to him or her through both relocation and accentuation of the perceptual act. In *Noisefields* and *Land of Timoteus* visual tropes explicate the active cognitive processes at work in even the simplest act of perception. At some level these works seem to interpolate the phenomenological subject, the self-aware viewer engaged by Maurice Merleau-Ponty.[10]

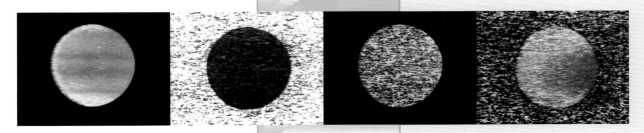

FIGURE **8** Steina and Woody Vasulka
NOISEFIELDS 1974
Video-still sequence

55

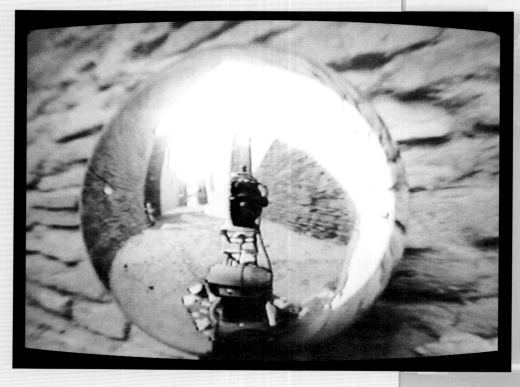

FIGURE 9 Steina
THE WEST 1983
Video still showing the Allvision machine

56

Objects and their systems of representation are treated in the Vasulkas' videotapes as neither self-evident and natural, nor simply available for reproduction. Yet if video here becomes an apparatus for underlining subjectivity, it does so while undermining the sure, safe, and familiar placement of the subject as observer of a world believed to be known. In the Vasulkas' other videotapes and in their installations, the acts of perception are multiplied and varied with great complexity; these works in one sense continue to address the phenomenological subject, but also question this construct. Perception is troubled, treated ironically and metaphorically using devices with a rich history of irony in the pictorial scheme. For example, Steina's *Allvision* (1976) recalls the convex mirror of the Renaissance most famous for its appearance in Van Eyck's *Giovanni Arnolfini and His Bride* (1434). These traditional devices are coupled with others that are new by virtue of their mechanized movements or electronic basis. Human vision is countered with machine vision. The parallels and discrepancies between what machines present to us and our recollection of unmediated vision are one "object" of our gaze.

THE MIRROR, THE PANOPTICON, AND MULTIPLICITY

In a series of recent installations, Steina's interest in both human and technological interaction with landscape and architecture are manifest. *The West* and *Borealis* (1993) both reexamine landscapes. Panopticon vision, historically introduced by the wide-angle lens, composite photography, and the cinematic 360-degree diorama, is automated in *The West* through the use of a machine Steina calls "Allvision" (fig. 9). The camera's 180-degree, wide-angle lens rotates while aimed at a mirrored globe, so that its image contains a second 180-degree reverse image while sweeping across a 360-degree field. The image produced in *Allvision* (pl. 3) with its globe is not only a 360-degree pan, but one in which each pole of the 180-degree arc is simultaneously present, the "back view" inside a centered circle, the forward distance framing this circle. Steina's Allvision

machine is paralleled by the omnidirectional camera in Woody's *Theater of Hybrid Automata* to sustain a hyperpanoptic gesture across their work. Inherent in this gesture is a survey of space that extends the conic vision of the subject into a powerful sweep of all that surrounds a central location, a metaphoric exploration of vision's power, geometry, and limits. Michael Snow's *La Région centrale* (1970–71) explored this metaphor of a circling, machine vision by taking its rotation systematically around a spherical course in the midst of a landscape in a day-night cycle. As in Snow's film, the tropes generated by the evocation of panoptic vision in *Allvision* are multiple and contradictory. Enveloping, flowing, repetitive cycles generate one sort of association, while the fragmentation of various image frames and analytical trajectories generate another. We are engaged in a vision that is fully imbued with both the sensation and the promise of power. A central tower surveying a surrounding prison is one aspect of the power engaged by the panopticon, as established by Jeremy Bentham and elaborated by Michel Foucault in *Discipline and Punish*.[11]

To overcome the limits of a fixed position in space and to be capable of surveying all who could threaten or attempt to escape one's control is a motivation for the tower and the turret of the panopticon. Through exaggeration, the Vasulka's hyperpanopticon becomes in part a parody of the paranoid desire to seek, know, and control everything, a wish already embedded and automated in the use of video for surveillance systems. Yet in *Allvision,* the inscription of panoptic vision is already deeply phantasmic and playful, like the vision sought by children as they whirl around, including the additional points of view afforded by such toys as swings and merry-go-rounds. Ominous and delightful, powerful and innocent, the panoptic vision is an oxymoronic look at its domain.

In *The West* the panoptic vision comes as the middle segment, after a section in which hand-held camera footage is combined with selective colorization to etch out the architectural forms of the Chaco Canyon ruins. The blue that fills in and accentuates the

shadows on the golden stone construction just barely denatures the image, lending an uncanny, emphatic quality to the ancient construction that could almost seem a natural element of the western landscape, so keyed is it to earth and sky. Then comes the panoptic survey of a desert landscape that includes the Very Large Array (VLA) satellite antenna installation and a forested landscape. Alternation occurs between natural and built environments, sometimes within the same image. The circular "insert" (of the mirrored sphere) shows primarily the artifacts of military science, while the frame shows the natural landscape that lies in the other direction, or vice-versa. *The West* consists of a bank of monitors, in which a series of wipes splits the screen further as one image progresses across another. Alternate monitors carry images from two channels of the videotape, a checkerboard pattern of repetition and variation that is constructed at times to graphically match the wipe movements. When the wipes match, they transcend the limits of the individual monitors and create flowing imagery.

Metaphors are engaged in *The West* that do not simply rest on obvious or singular interpretations. One could read the work as a poetic indictment of the contemporary reconstruction of this space for industrial and military purposes, or conversely as a fascination with the forms that obliterate such a political reading through an equally poetic vision of both nature and culture. Such readings are not only too partial, they miss the problematizing of image-metaphors at the heart of the work. The nature/culture opposition does run through the installation, reiterated in the opposition of the machine (that produces the vision) to the humans (who make and see that machine vision), but is only a preliminary proposition. Once made thematic, the opposition is varied and left to reverberate as a more fundamental questioning of a subjective placement—how this subject is located within this world.

The geometries of the Allvision machine's rotations in several of Steina's videotapes suggest the obvious metaphor of reflexivity, especially when the video camera or its shadow appears in the

57

image. However reflexivity is presented with such variation that what by now has become self-evident within modernist reflexivity is troubled. Even if we are shown and know all the components of the construction of an artwork, do we know anything more of the process of textual construction? Reflexivity in art has been for the most part limited to externals: the filmmaker in the film, the camera in the image, the characters speaking as actors. Not that the music of these spheres is simply better left to an appreciation that remains magical; the geometries of *Allvision* suggest perhaps that the deconstruction of metaphysics needs more than the merely physical reflection on the apparatuses of production.[12]

Borealis (pl. 6) continues this exploration of reflexivity and redoubled vision of landscape. This installation clarifies and makes most direct its reference to the northern lights in its inclusion of a pastel image of Steina's shadow surrounded by a halo glow as she shoots images of an ambiguous vaporous landscape of either steam or fog. In this image the artist is a shadow figure both surrounded by and creating an image of light in reference to and in memory of the seasonal atmospheric light of her native land. In *Borealis*, four translucent screens bearing projections of images shimmer with a diffuse color that makes the most, aesthetically, of projected video. The images of various landscapes and seascapes, familiar elements of Steina's work, seem chosen for their water-rushing, branches-swaying rhythms, which are subject to inverted motion. As installation, *Borealis* fills its room, inviting spectators to wander through its images, while their trajectories gradually generate new possibilities of response.

Borealis is a work that emphasizes the present moment of intervention in the history of film and video installation; as new projection technology makes video more like film, it annexes film's light, but acquires video's quality of light and color, its unique image processes. Video here also takes the part of environmental sculpture, drawing, like artists' attention to rocks and earth mounds, a relation between an external environment and a

manifest installation. The environment becomes manifest as it is made evident to the senses as a means of understanding. The place of *Borealis* is both interactive as well as manifest; patterns of imagery across numerous screens set at dispersed angles introduce poetic and/or serial structure and notions of sequence. Changing image relationships emphasize graphic rhymes, matches, and echoes, complicating our perception of movement. The viewer practices the skills of divided and selected attention, as they randomly select elements in the installation on which to focus and about which to think. Yet the translucent screens also insist on the two dimensionality of video representation, in the manner that the image stops at the screen, giving us only its spatial inversion for the other side.

That is what has always been at stake conceptually in the video installation—a placement in space of viewing, the subject implicated spatially in the text's display, actually moving around it, through it, knowing that its representational illusions are presented in combination with a space that is not illusory, but actual. The viewer is phenomenologically implicated in the apparatus of representation, as he or she moves through a space with pretensions of reality, for all the thoughtful illusion it provokes. Yet this space conceptually wavers because of its physicality and its abstraction, its insistence on making actual its metaphors, on confronting the viewer with objects and representations, with space felt through the body and the space of visual illusions at the same time. These spaces of representation are also spaces of presence, forcing the viewer to conceive of herself or himself in the act of watching. The spectator then seems to occupy two spaces at once. There is always something of the uncanny in such doubling, like the statue so real it seems ready to move.

Borealis, in its reference to the ephemeral lights that embellish a horizon with a most illusory presence, suggests that a theory of video installation might think through the phenomenology of space and specularity from a deconstructive angle. For

if the monitor roots the image in its presence as part of an apparatus, an installation such as *Borealis* plays on the doubling and splitting of the image as nonpresent, as illusion and suggestion.

META-ART PROJECTS

 A number of the Vasulkas' videotapes engage the history of the arts in a critical and self-reflexive manner, either as a comment on art history, as in *Golden Voyage* (1973), or as an appropriation of music history, as in *The Commission* (1983). *Golden Voyage* replicates *The Gilt Legend* (1956), a René Magritte painting of loaves of bread suspended in the sky, but places the loaves in motion, drifting across the screen. Arrested movement, displacement of objects from their "proper place," and the inversion of literary metaphors through their visual literalization (floating bread as manna from heaven) are what make the Magritte surrealist. The reproduction of Magritte through a playful refiguration suggests that video is automatically surrealist, as it is able to electronically dissect the picture plane, literalize the movement, and accentuate the collage-like presentation of objects set against imaginary grounds. The instantaneous multiplicity of imagery produced by keying and switching in video performs as the automation of a modernist art movement.[13] Similarly, *Digital Images* suggests the fractured imagery of analytic Cubism, or at the level of pixel organization, the Pointillism of Georges Seurat. These works demonstrate that video can be programmed to automatically replicate any and all styles of representation throughout art history, not as simple reproduction but as an elemental reworking.

Unlike predigital photography whose automatically replicative capacities were limited to copying the original work, video first made it possible to recreate the processes or effects of image construction by breaking into the image surface through electronic reconstruction of the signal. Each and every point on screen can be reworked in relation to the others. Handcrafted techniques can be instantaneously imitated on various image sources. A colorizer can be adjusted for fauvist effects, scan processing can warp a figure forward from the picture plane like a Donatello bas-relief, rapid switching can simulate cubist multiplicity of perspective. If photography became an important stage in the history of art in part through its reproductive capacities, video is shown to be an equally significant device in its ability to reproduce non-Euclidian geometries, differentiated image planes, and a selection of surface texture and color.

The implication of this incorporation of art history into the Vasulkas' video, if read strongly, can be a reevaluation of the relationship between art and history not unlike Michel Foucault's conception of discursive formations, in which history operates through the decentralized dynamics of implicit rules that govern disciplinary discourses. The Vasulkas' reference to specific painters similarly rehistoricizes art in terms of rules or regulations that can be programmed into the video apparatus. Art history becomes spatialized in the process, with each period and style reconceived in terms of boundaries and internal organization. Yet the material does not become dehistoricized, as Fredric Jameson argues occurs in postmodernist conceptions of art.[14] Rather, the manner of intervention in history is reformulated.

Woody continues this process of spatializing history in his recent narrative works, which may appear at first to be unrelated to previous concerns. In *The Commission* (pl. 13), an incident from music history legend becomes the source of narrative and formal development. Niccolò Paganini acted as go-between for a newspaper editor's commission of a piece by Hector Berlioz. The recounting of this tale in video unavoidably suggests the contemporary problems of art funding in the United States and the process by which a panel of artists or experts evaluate competing grant proposals for public or private funding agencies. Paganini's virtuoso violin performances, however, resonate with Steina's past training and performances on the violin, as well as with the

operatic form of *The Commission*. The past is situated at a balancing point between personal memory and public history. This conjunction occurs in the desert, with European characters displaced and relocated to the landscapes of the Southwest. The desert seems to function as a metaphor for America as zero-point of historic traditions, an imaginary antithesis of Europe, as it does in Jean Baudrillard's *America*.[15] As immigrants, Steina and Woody Vasulka seem to share elements of Baudrillard's vision of America. Yet history is not absent, but refigured. Using video as the form of inscription selected for this new historical opera allows for the tradition of the spectacle to be reinscribed as a text of sound and image. The desert is therefore also a place where history can be freshly reexamined, where displacement works to overturn the myths surrounding performing artists. Art history need not be an embrace of the cult of personality, but a reflection on the historical transformation of forms and a study of how art is commissioned by forces that involve both the personal history of the artist and the history that surrounds him or her.

Art and history are similarly reconfigured in the 1987 work *Art of Memory* (pl. 15), which evokes the iconographic heritage of World War II in the form of film clips, among which are films from UFA, the German national film industry, and newsreels from the Spanish civil war. The films are displayed as strips of images suspended in the desert, laced through the dynamically fluid shapes and multiple frames that digitized video can create within the video screen. A landscape of displacement and fantasy, the desert wilds of the Southwest are not so much background as overlay, interposed in tension with these haunting images from the past. The desert here echoes its use in *The Commission,* as an absence of history that frames historical material, filmic material.

Woody's work primarily shows the haunting of images that can't be entirely worked through or forgotten, as well as the ironies of our fascination with visual power. It introduces an intense subjectivity, beyond the flashback's controlled subjectivity of history

that narrative film uses to frame and legitimize the past. It also opens the possibility that a sense of history can emerge out of a different presentation of the icons of history, though here much is dependent on the spectator bringing to the text both points of reference and active critical engagement.

MACHINE GENDER

During their artistic careers, Steina and Woody Vasulka have produced and signed their work both collaboratively and as individuals. Their individually named pieces allow, in part, a concentration on gender that now inflects previous concerns with perceptual-cognitive effects, tool reading, and landscape. In *Lilith, The Brotherhood,* and *In the Land of the Elevator Girls* (1989), gender becomes a figure through which to rethink the positioning of the subject in an electronic context.

The performance of actions in Steina's video work often hints at self-portrait and autobiography, hints so subtle that they depend exclusively on the locations chosen, images of the artist, and the instrument she plays (the violin). In *Lilith* (pl. 16), these hints are replaced by a reference to myth that augments this indirect self-revelation. Here Steina attempts to infuse her considerable vocabulary of image processing and her unique sense of rhythm with metaphors garnered through a mythological and literary reference.

The "Lilith" of the tape's title is a fascinating figure in Judaic myth, with antecedents in Egyptian, Babylonian, and Greek culture, where she, under different names and manifestations, appears as a she-demon who seduces husbands and either bears demon children with them or kills the children issued from their official marriage. In some versions she is beautiful, in others a hideous lion-like monster. In the Talmudic period Lilith is the first wife of Adam (a transformation of her Greek figuration as another wife of Zeus). In Jewish myth, she remains a figure in cabalistic and, later, Hassidic Judaism, where she functions to embody an evil spirit

against which an amulet, a *Kimpesettel* in Yiddish, bearing Hebrew prayers will suffice to save the birth of a child, and later protect the child's bedroom.[16]

The appeal of Lilith from a contemporary feminist point of view is as an image of female power, one perhaps doomed historically to be seen as threatening and a demonic force. Steina creates in *Lilith* her work most directly accessible to feminist analysis, and one in which she collaborates with another woman, Doris Cross, who embodies Lilith.

Layers of imagery using the familiar analog processes of a keyer create the image of a portrait against a landscape which we take to be the Lilith of the title (fig. 10). The portrait image appears to occupy a "foreground," but is in fact layered images of more than one camera view. Positive and negative images are superimposed, each representing at times a slightly different temporal or spatial articulation. The keying allows one portrait image to bleed through the other. Thus the layers of this Lilith portrait are both separate *and* fused with each other, existing in the visual space of the other that recalls Picasso's later, so-called decorative cubist portraits, such as *Girl before a Mirror* (1932) and *Seated Woman* (1938), which superimpose and blend, more straightforwardly than in analytical Cubism, profile and frontal views of the model. The landscape "background" is also complexly articulated, for when Lilith is at first pictured in front of it, the woods appear to bleed through the keying in both portrait layers. Later these images of woods appear as independent passages of trees alone between each "act" of Lilith's performance. Still frames and shifting focus, plus the ghostly doubling of branch movement, create abstract rhythms to these alternating separate passages.

The videotape presents five separate segments of Lilith's performance. First, she seems a conjuring witch, suggestively conducting a magically invisible orchestra, her clapping emphasizing the hint of a casting of spells. Next she begins her acts of

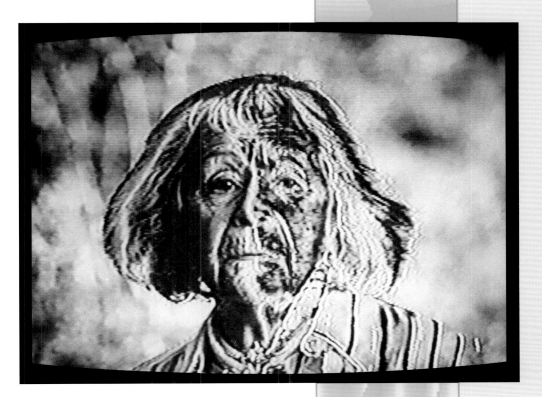

FIGURE **10** Steina
LILITH 1987
Video still

61

enunciation. Her face in double-camera view creates here two distinct temporalities with more discrepancy between frontal and profile views, as her head turns and lips move out of sync with her voice. Her lines are electronically processed sounds, inverted temporally to emerge as primal grunts. In the third segment, her hands prominently gesture with her enunciations, while in the fourth she clearly begins to say "no." The fifth segment elaborates this "no," by combining it with her head-shaking in a most lion-like display of a waving mane. Altered images of tree motion seem to make a visual allusion to the swooshing sounds of Lilith's incantational articulations. Spirit, witch, lioness, the Lilith of Jewish mythology here joins her nordic sister spirits, goddesses of the woods and sea, tree spirits, and mermaids.

Lilith can be seen as an ode to the beautifully aged, dynamic female face. It also generates a dynamic and suggestive poetics of visual elements and referential traces. Abstract aspects of image timing and composition are allowed to accrue meanings that annex those that are more literary and mythic, without ever becoming mere illustration. The suggestive poetics here remain focused on the power of video elements within the composition.

Woody's *The Brotherhood* (pls. 7–8) similarly inflects previous concerns with the issue of gender. In one sense, *The Brotherhood* continues the examination of how supposedly neutral machines incorporate Western logic and cultural history, extending the reading of tools from *Digital Images* and *Theater of Hybrid Automata.* As with *The Commission* and *Art of Memory,* an ideological analysis is woven into artistic materials. In the past, the Vasulkas have gathered surplus parts from across the United States to incorporate into their electronic projects, remotivating devices found in government and commercial warehouses for the purposes of art. *The Brotherhood* inverts this process to foreground the military context as the source of much of the machinery that now surrounds us, speculating on the kind of intelligence that is built into these devices.

Much of the refuse in *The Brotherhood* comes from Los Alamos, near where the Vasulkas now live, and embodies traces of the Cold War. Table I displays plotting devices, originally used, presumably, to map military interceptions; these become a metaphor for the unrecognized violence that is implicit in Western philosophy's desire to know, unconsciously driven by the will to power. *The Brotherhood* is a reminder that the genealogy of the internet leads back to the Defense Department's ARPANET, originally designed as a military communications system that could survive a nuclear attack. After the Oklahoma City bombing, the effects of militarized knowledge have become more obvious, as the violence

FIGURE 11 Steina
IN THE LAND OF THE ELEVATOR GIRLS 1989
Video still

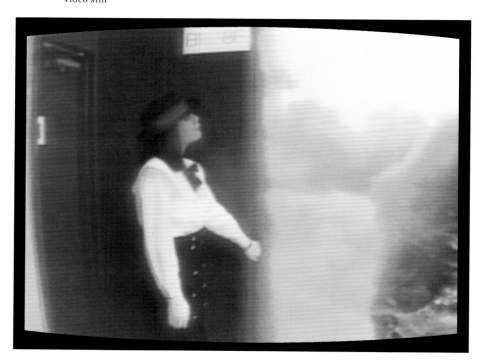

READING THE TOOLS, WRITING THE IMAGE

once directed outward toward external enemies becomes redirected inward, toward U.S. society itself. Yet Woody represents the violence implicit in human innovation and intelligence with some sympathy and irony.

Significantly, *The Brotherhood* represents this conjunction of violence and machines in gender terms. In the discourses that surround machine intelligence or the "emergent properties of complex dynamical systems,"[17] it is often male intelligence and properties that are assumed to be inherent in the machine. Implicit in this installation is a question about the retooling of male identity. Can a post-nationalist society learn to negotiate aggressivity and violence, which seem somehow disturbingly linked to innovation, without dissolving into self-destruction?

Steina reconfigures some of these same issues in a comic and cross-cultural context. Visual jokes that suggest a critical commentary on the function of ritual in Japanese culture punctuate *In the Land of the Elevator Girls* (pl. 17). The title and opening images of the work refer to the women hired by large Japanese department store chains not only to run the elevators (which are now automated) but to greet passengers entering and leaving these transportation devices. In smaller buildings these greetings are sometimes offered by recorded voices—the elevator itself speaks its welcoming and departing greetings.

In the videotape, we see these employees in opening shots that economically present three examples of the rituals in different stores, identifiable not only by the differently designed elevators, but by different uniforms on the women. The most startling in the series is the second, in which women who appear to be identical twins perform their greetings on either side of an open elevator door, shot at an angle from the interior looking out. Their matching hair and physiognomy augment the uncanny uniformity of outfit and gesture. Then in the third elevator shot, the opening is both a joke and a surprise. Our attendent entreats our departure into a roaring volcano that has been electronically imposed on

the right half of the image (fig. 11). Then the "actual" elevator sequences of the tape return, with a view of an employee offering greetings in the public space of the store, but the image splays out the elevator wall by grabbing segments of the frame. Time-delay couples with internal repetition to create an image of space like an unfolding paper fan.

What is established in Steina's rapid-fire jokes on ritual and image is a complex relationship between social observation and commentary on one hand, and video processing and the imagination it affords on the other. The elevator openings seem to fascinate precisely through their relationship to video wipes across the screen. A comparison is being drawn between the way in which elevators are devices that open onto space in repetitious intervals, filled with potential discoveries and surprises, and the video artist as tourist in Japan, discovering and uncovering its sights as potential video images.

From here we move to an electronically processed "elevator door"—one that looks like a constructivist design in shiny steel, parting at a band in the center of the image. It opens successively on a series of spaces that extend a visual pathway down the center of the screen: a zoom forward on a curved bridge in the rain, a more rustic covered walkway down which a gardener walks. Images of conveyances and performances then follow: an escalator coming up from a deep subway, a glass exterior elevator at the corner of a Ginza building lit in its night neon, a Shinto ritual, and an avant-garde performance edged in neon and featuring VR-type goggles. These glimpses view Japan in its compositional propensities of visual elegance, spectacle, and ritual, framing, so to speak, the elevator employees in their cultural context.

It is not to them that the work returns at the end, but to the commercial spaces of department stores, restaurants and hotels, now revealed by elevator doors and electronic wipes combined. The videotape has secured its trope of wipe/door opening as an image in a certain sense beyond the play of metaphor; video wipes

63

and elevator doors are actualized in this work as mutually inter-dependent. The videotape is light and moving at the same time; a serious joke on space and temporal change, on architectonics and the state of Japanese cultural flux.

Just as electronic wipes and mechanical doors become inter-dependent in a single trope, so human behavior and mechanical repetition become entwined in an automated environment. The elevator girl is in a sense like the video artist, inviting the public to cross boundaries into different spaces. The consequence is a series of gendered thresholds, opening onto sometimes wildly dis-junctive and even surreal possibilities, as natural phenomena and cultural practices erupt within automation.

Throughout this essay we have attempted to see the Vasulkas' work not only as the product of their intentions or as trails blazed by two video pioneers, but as works which become increasingly intriguing in light of contemporary theories of the image, writing, and perception. Methods of textual and cultural analysis rework preconceived notions of the artist as a central unifying force that controls his or her work. Instead, artistic work acts as a dynamic intersection of multiple and even conflicting ideas, deeply con-nected to the world. If approached through an active reading, these texts can teach us how to understand some of the complex processes of cultural change that they embody.

Notes

This is a shortened version of a more extensive essay on the Vasulkas' work.

1. Jean-François Lyotard, *The Inhuman,* trans. Geoffrey Bennington and Rachel Bowlby (Stanford: Stanford University Press, 1991): 3.

2. Originally a stereo (three-dimensional) film of a video screen, *Time/Energy Objects* was converted to videotape in a 1978 compilation for WBFO-TV in Buffalo, New York.

3. See Woody Vasulka and Scott Nygren, "Didactic Video: Organizational Models of the Electronic Image," *Afterimage* 3, no. 4 (October 1975): 9–13.

4. Unlike other videotapes in the *Vasulka Video* series that compiled excerpts from ear-lier work for broadcast on public television, *Digital Images* includes material not available elsewhere.

5. Quoted in "Woody and Steina Vasulka: From Feedback to Paganini," interview by MaLin Wilson and Jackie Melega, *Artlines* (May 1981): 10.

6. Ibid.

7. Nicholas Negroponte makes a parallel contemporary point about the conflicting demands of high-definition television (HDTV) and digital connectivity in *Being Digital* (New York: Alfred A. Knopf, 1995): 21–36.

8. Ulric Neisser, *Cognitive Psychology* (New York: Appleton-Century-Crofts, 1967).

9. See Maureen Turim, *Abstraction in Avant-Garde Films* (Ann Arbor: UMI Press, 1985), especially the chapter on the flicker film entitled "Flickering Light, Pulsing Traces," 93–106.

10. See Maurice Merleau-Ponty, *The Phenomenology of Perception*, trans. Colin Smith (London: Routledge and Kegan Paul, 1962): 57.

11. Michel Foucault, *Discipline and Punish: The Birth of the Prison*, trans. Alan Sheridan (New York: Vintage, 1979).

12. Medieval cosmology imagined astrological influences as a musical resonance of the heavens' orbital spheres with the human subject; if *Allvision*'s visual spheres recall such an integrative scheme, they also displace it.

13. The Vasulkas produced *Golden Voyage* with George Brown's multi-layer keyer, before digital video made multiple-image layering easily available.

14. Fredric Jameson, "The Cultural Logic of Late-Capitalism," *New Left Review*, no. 146 (July/August 1984). See Turim's discussion of this in "The Cultural Logic of Video," *Illuminating Video: An Essential Guide to Video Art*, eds. Doug Hall and Sally Jo Fifer (New York: Aperture, 1991): 331–42.

15. Jean Baudrillard, *America*, trans. Chris Turner (New York: Verso, 1988).

16. See Theodor Gaster, *The Holy and the Profane* (New York: William Morrow and Co., 1980): 19–27; and Joshua Tachtenburg, *Jewish Magic and Superstition* (New York: Behrman's Jewish Book House, 1939): 280. This mythological tradition survives into the modern world not only through regional legends, but through a wealth of literary references: in Shakespeare, Goethe, Rosetti, and later in George McDonald, C. S. Lewis, Charles Williams, and J. R. Salamanca. Through adaptations of Goethe's *Faust,* Lilith figures in German film, and meets U.S. film through Robert Rosen's 1964 adaptation of Salamanca's *Lilith* where the goddess figures as metaphor for a fictional psychoan-alytic case history.

17. Woody cites this phrase in his working papers for *The Brotherhood*, in a discus-sion of currently fashionable rhetoric for what used to be called machine intelligence.

Notes on Installations:
From Printed Matter to Noncentric Space

WOODY VASULKA

Initially I looked at video installations with a great deal of suspicion. I was a man of Printed Matter. I used to believe strongly in the powers of the immaterial image, in those cognitive units of energy organized in time. I believed that the time had come to do away with the gallery, as the last of the oppressive control of art. And I certainly belonged to the group that Jonas Mekas at the end of the 1960s called the "tribe that worships electricity." So, what is this current obsession of mine with making "TV furniture" in museums and galleries?

It may seem ironic that in constructing my new installations, such as *Theater of Hybrid Automata* (1990) and *The Brotherhood* (1994–96), I am filling the space with objects of a menacing character. My backyard junk pile contains some remarkable pieces. The device at the heart of *Theater of Hybrid Automata* was once a celestial navigator, a double cylinder with optics and sensors to keep the instrument locked to the polar star. Obviously this was a piece of military hardware, designed to drop its deadly cargo somewhere in terrestrial space. The questions Where am I? Where am I going? and How am I getting there? are encoded in intercept plotting tables, gyro-heads of missiles, tracking devices, and other opto-mechanical junk. Now these devices idle in the junk fields of the Southwest, their electronic nervous systems, their hydraulic and pneumatic networks, ripped apart, bleeding.

When I reached an impasse in my work with the cinematic-electronic frame, I turned my attention to this sinister arsenal, giving it a chance to manifest a different final destiny. I had neither the tools nor the knowledge to continue my narrative quest in three-dimensional graphics. I had battled the software and the machine until I realized that it was my head that needed realignment. This may, at least in part, explain the depth of my betrayal of immateriality and, therefore, the sudden appearance of installations in my recent work.

Of the attempts made to influence the early formation of my ethical code, the one that left the most permanent impression had to do with money. As Catholic boys in the suburbs of a Moravian town, we were constantly reminded by the chaplain, and later by the priest himself, of the dangers of even thinking about money. Later in school, the socialist doctrine was no less

compelling. It was inconceivable to lust after money in public or within my circle of friends. We looked down on our fathers' attempts to pocket cash with their petty schemes of smuggling food from the countryside to the city right after the war, when food was scarce. In our youthful utopia, we talked of poetry, modern art, and jazz.

Fortunately, I could not draw. None of my lines or strokes would ever resemble a divine connection with the Ultimate. What remained was writing, poetry, music, and photography. So it was out of my ineptitude that I formed an ethical bond with the concept of Printed Matter. I was committed to the universality of the replicable template, to all codes conceived in an immaterial context, in a total privacy of time and space, to everything that had to do with facilitating the metaphysical flow of ideas, the most powerful tool of utopia. All of this without the charade of a museum or gallery, without the seduction of the bourgeois, to whom or to what even the most incorruptible sooner or later fall prey. And video? This is Printed Matter par excellence! It was a simple technicality to embrace this ideal, the abstract template of electronic media, duplicable, self-publishable. Without any social status, without having to play the entertainer, clown, or fool, an author, well-hidden in the labyrinth of his mind or in his studio, could suddenly reach out to the world.

In making films, I dreaded the bombastic, public phase. As a shy, young man I found everything associated with public rituals intimidating. My pleasure was to edit film. This intimate protocol of joining two parts to build a far higher meaning suited the temperament of the practicing poet I considered myself to be.

With video, I became an instant voyeur. When I made video feedback for the first time, I would step back, watch, and then quietly slip out of the room, knowing that the feedback was still there, that it was alive and improving itself each moment, and that it was getting more and more complex and robust. I understood the consequences this could have on the rest of my life. Even now, when I

seed a bunch of dubious numbers into my computer, I watch the chaos unveil with the same fascination.

Video came so fast; it was so new. We all plunged into a frenzy of handling this hot new stuff called video. There were so many things to learn in a short time: this new picture material, so mysterious and seemingly untouchable, these frames, "drawn" and suspended by a magnetic force on the face of the cathode-ray tube. But there was much more to know: the nature of image elements; the waveforms, their unity and exchangeability with sound, their mutual affinities and interactions; the craft of creating waveforms into primitive aesthetic units, which would survive the critical scrutiny of art.

Analog video was just the beginning. By the mid-1970s, with the aid of the Digital Image Articulator (built with Jeffrey Schier), I was peering into an entirely different, completely unfamiliar— but even more intriguing—window. The process of constructing a digitally organized screen is one of the most exciting experiences I can remember. I watched as a linear array of numbers hidden somewhere in a computer came out orderly, constructing point by point a visual, cognitive, perceptual unit—a frame. This point-by-point progression of frame construction is accomplished by the mere addition of the number one. To start constructing the next line, the binary counter steps into the next numerical scheme. This goes forward again and again with the same assurance as the sun rising each morning.

Even more dramatic was the realization of the intrinsic duality of the code that creates the electronic frame. Not only do the counters transform computer memory into the territory of the screen, each carries an actual image property: the expression of point/image, the number representing brightness or color—a tiny part of the image itself. And that's not all. Deep in the heart of every computer there is the "legendary" Central Processing Unit (CPU). Through it, everything could be reorganized with infinitely changing strategies. The drama comes from watching each line

being drawn, each frame as a narrative assembly. No wonder I was transfixed by this kind of television.

Paradoxically, that experiencing of the code became instrumental in terminating my interest in the image as frame. Although the convenience of a frame is used to pass on an iconic shorthand, I finally realized that the radically *new* is not in the invention of a new image or even in a new set of syntactic devices as I had expected, but in the form of a gift offered to us by the machine: a new and undefined representation of space.

Cinematic space operates on two opposite narrative vectors. If space is represented by a sphere, the first set of narrative vectors looks at the point in the very center of all possible angles. The other, the opposite set of vectors, looks at the surface of this imaginary sphere from a center point on the inside — again, an infinite choice. For pragmatic reasons, cinema chooses a largely reduced set of vectors. The reduction of cinematic space is related to the strictures of practical access to all these locations by physical means, such as the constraints of horizontality and verticality of the environment, earth gravity, and other physical conditions of space. Above all, the limits of selecting the set of cinematic vectors depends on the implementation of concepts of psychologically dominant human viewpoints. Cinematic space thus represents a significant reduction of the potential exploitation of the available zones of all-directional space.

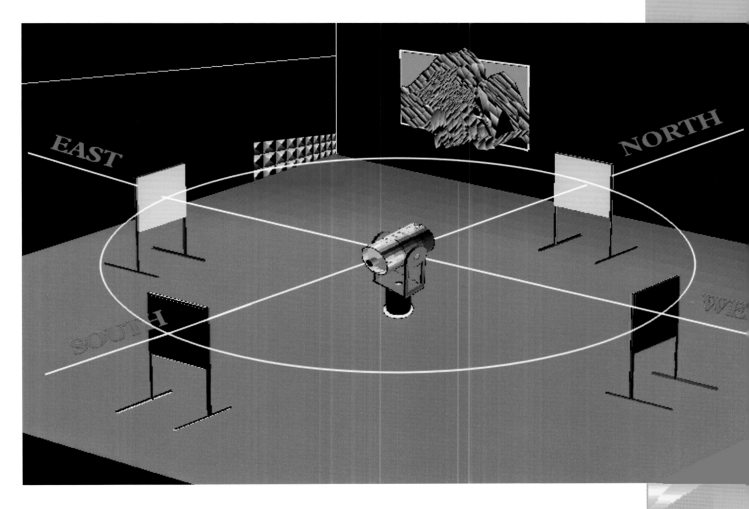

FIGURE **12** Woody Vasulka
THEATER OF HYBRID AUTOMATA 1990
Computer-generated study

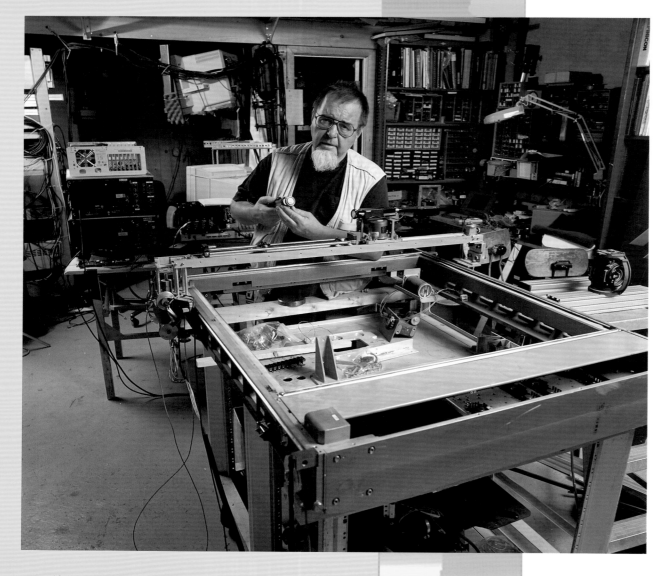

There is no convincing or practical method to transpose the filmic world of light and shadow into the world of the computer. It is indeed this generic incompatibility, this artificial condition, that is the subject of my interest. I see film becoming a dysfunctional and alien element in the new digital space. The primary concept of the new space is expressed by the continuity necessary to represent multidimensional image/objects. Once constructed, the scene becomes a subject of recall, held indefinitely in the computer memory with all its previous conditions intact, including the continuity of all surfaces, equally significant and accessible from all directions. This is unlike film, where once the frame has been constructed and shot, space continuity is routinely discarded.

Furthermore, digital space has no generic method for looking at the world in the way that a camera does through its pinhole/lens apparatus. Digital space is constructed space, in which each component, aspect, concept, and surface must be defined mathematically. At the same time, the world inside a computer is but a model of reality as if seen through the eye of a synthetic camera, inseparable from the tradition of film. Yet, in this context, no viewpoint is ever discarded, the internal space is open to a continuous rearrangement, and access to a selection of views and narrative vectors is infinite, not only to the

author, but also, with the use of certain strategies, to the viewer. Once the author constructs and organizes a digital space, the viewer can enter into a narrative relationship with it. A shot in film indicates a discrete viewpoint. Its narrative purpose is to eliminate other possible views. In contrast, the world in the computer contains the infinity of undivided space, undissected by the viewpoints of narrative progression. In the world of the machine, all sets of narrative vectors are offered in an equal, non-hierarchical way. The machine is indifferent to the psychological conditioning of a viewpoint. All coordinates of space are always present and available to the principles of selected observation.

The new space offered by the computer is a "noncentric" space with no coordinates. One must cross the threshold of the filmic or the electronic frame and fully enter this new space. As in the primordial forest, all directions are equally new, equally important and challenging. And in this forest, the event becomes the narrative drive. Is it the sign of danger that might have caught our attention? Is it the clue left by the predecessor on the forest floor? Is it the sound of the falling tree? Not all the events appeal just to our instincts. Inevitably we bring to the new space our cultural knowledge, our intellectual curiosity. Although the author will prescribe the event, more than ever we become partners in his play.

Theater of Hybrid Automata (pl. 5) is a direct result of a discourse between my understanding of traditional cinematic space and a newly emerging digital space. To chart the first set of vectors, I built a camera head capable of being aimed at any location in space from a fixed point. This elegant version of space exploration should have been a simple project for a computer. Instead, I entered a long and cumbersome period of constructing this physical apparatus.

Again, I had no elegant solution to express the second set of vectors. Jeffrey Shaw brought a brilliant solution to my dilemma in a work titled *Golden Calf* (1993) by using a hand-held monitor with a positional tracking device. By constructing an object completely in the computer memory (including the reflections of the environment on its surface), one can walk around this virtual object by holding a portable LCD screen, looking and observing the virtual version of the object. Through a positional tracking device attached to the computer, the screen becomes the medium between the object and the observer. Any change in the angle of the observer's screen will force the computer memory to reposition the virtual object on that screen. The real and the virtual are in mutual embrace. To me, this presented a clear demonstration of the second set of narrative vectors of cinema performed virtually and in action. These were clearly the opposite vectors to those of my looking-out device. This time I saw space staring into a point.

The dual concept of the project of *Theater of Hybrid Automata*— the actual physical construction of space and its virtual representation through the computer—is performed in a strict positional interlock, so that any change in the physical is accompanied by a change in the virtual. The common engine of the computer gives the coordinates to both the physical space, as defined by the robotic devices, and the graphic representation of the three-dimensional world. For the first time in my work, the images provide a purely referential function. The prerecorded spatial icon represents a mere allegory of space, and the numbers are simply consequential symbols of incremental values. Like the voice reading the terrestrial alignments from the perimeter of the compass, the significance of the images is reduced to their function as indexes. They no longer compete for all-out dramatic attention. Perhaps then the liberated viewer has the opportunity to contemplate events suspended in a web of polytopic and polychronic narrative stratifications.

Hence, *Theater of Hybrid Automata* gave me a chance to reflect on several questions of space. First, there is the space continuum raging on without known limits. I have carved from it a type of weather converting unit I call my studio—a house with floor, walls,

69

and roof. Inside I built the physical construction—the cube as an abstract, dramatic space. The lines of this construction are straight, linear, extraordinarily rational. Next, in my computer, I constructed a representational form of this local space in the form of a three-dimensional graphic spherical icon, rendered with a slightly transparent skin and with small referential objects inside (fig. 12).

Outside the cubic construction in the studio is the terrestrial world, bound to the surface of the globe and unable to escape the curvature of the earth. Beyond earth is true space, where nothing is linear, nothing horizontal or vertical. In space, there is no up or down, no roads, surfaces, tunnels, or narrative pathways, no shadow to shield the spirits.

The presentation of the installation in the shell of a gallery indicates the first level of localized Cartesian space. As the camera scans the targets, the words generated by the machine name the landmarks that surrounded the apparatus at its conception in the Southwest. In the next step of its performance, the machine addresses the extended terrestrial space by calling out the global markers of north, south, east, and west. The third level evokes the confrontation of the experience of local and terrestrial space with a graphic representation of space in the moving three-dimensional graphic icon.

I see *Theater of Hybrid Automata* as an apparatus that is conscious of space. The basic cyclical ritual of the machine, the process of calibration is a phenomenon performed at each and every moment whenever a machine charts its future. Perhaps it is complementary to our own human experience. From the moment of awakening, our mind begins the search for its identity, its alignment to time, the shape of a room, a street, a city. Finally, the way in which this assembly of objects, systems, and events behaves may help to trace some points of its original intent: to deconstruct, analyze, and describe the basic behavioral pattern of a techno-aesthetic system.

In the late 1980s I entered the world of interactive performances through experimentation with media on an interactive stage first realized in the design of a performance of Joan La Barbara's *Events in the Elsewhere* (1990). It was in that experiment that the video/computer installation of *Theater of Hybrid Automata* was first configured. I had experimented with interactivity in voice and vocalized commands using the Musical Instrument Digital Interface (MIDI) code. The MIDI code already carries the basic musical protocol, one that corresponds to the level of my need to control other media devices. An initial experimentation involved robotics and other media controlled by a MIDI code. Later I expanded this interface to a laserdisc player.

I had intended to build a fully responsive permanent interactive environment, but instead I found my efforts centering around building a series of tables titled *The Brotherhood* (fig. 13). The interactivity in *Table III* is designed to involve the random visitor in the gallery. While I approached this piece with a broad mandate for risk-taking, in the end I limited all possibilities to a few safe options. In principle, the installation performs its preprogrammed audio/video cycle; the overall composition progresses as a single time line unless the audience intervenes. The visual concept is based on a single light beam, split and redirected to the six coordinates of a cube. At the walls of the imaginary cube, there are six translucent screens, showing the projected images on both sides of the screens.

In *Table III* (pl. 7) the interactive laserdisc program is accessed via the audio component, either through a microphone or a drum pad. The MIDI code, extracted from the pitch of the voice, searches a location on the laserdisc. It just so happens that the human voice contains a wealth of musical overtones, and the device is more than happy to interpret them on a tonal register and to activate "jumps" in the laserdisc sequence. The other audio channel is a sensor monitoring the intensity of a drum beat. The assignment is linear—the softer the beat, the slower the movement of the laserdisc images,

the harder the beat, the faster their movement. A third sensor detects the presence of people in the space. If nothing moves in the environment for a while, the installation goes to "sleep."

As could be expected, the audience splits into two main categories: those who are active, interested in probing the installation, and those who observe, hesitant to join in. The core of active participants is drawn to playing the drum, paying little attention to the change in image they have produced. The microphone seems more intimidating. Loudness is usually preferred; the participation escalates to a frenzy, followed by an abrupt departure.

For me, the benefit of the interactivity goes to the true voyeurs who are detached from the situation and observing. Here is the moment of reflection, impossible to experience while engaged. But what did I expect from the audience? I have come to realize that I do not fully trust my audience. I do not give them the tools and the power of *composition*—I only allow them *intervention*. In fact, I recall watching viewers interact with this work with a great deal of resentment at how its "whole" was being chopped into meaningless parcels.

On the other hand, the pictorial and acoustical material of *Table III* is abrupt and violent in nature. The continuous and aggressive motion forward is designed deliberately to place the viewer in the seat of the projectile. I purposefully stripped all possible associations with a narrative, encouraging the audience to intervene at will and to pursue suggestions made by the author to *play* the violence of *The Brotherhood*.

In both *Theater of Hybrid Automata* and *The Brotherhood*, I attempt to transform a cubical Cartesian space into a dramatic space (fig. 14). In performance, the machine and the sensors under its internal communication protocol represent the first stage of a narrative probe. There could be many steps between these models and their transformation into the fully realized concept of an electronic stage.

To convincingly operate such a dramatic space, a certain number of expressive elements capable of monitoring, evoking, or

FIGURE 14 Woody Vasulka
THEATER OF HYBRID AUTOMATA 1990
Video still

71

activating events in a dramatic space must be present. They must be capable of interrogating or reporting on the status and changes in the space, correcting and navigating trajectories of gestures and other events, and initiating changes in space. The success of operating such a space depends upon certain qualities of the sensorial matrix—its density, its ability to discriminate the spatial coordinates, and its updating of time/samples to achieve the necessary dynamic resolution.

This new space offers a noncentric space with no known coordinates. Accordingly, no singular narrative pathway is feasible. The author is like an ancient guide with his instincts and worn-out charts, no more secure and surefooted than the viewer.

At least one aspect of thinking about the new space and the role of the gallery has come under revision in my mind. It is becoming clear that the real world has become hostile to any notion of utopian experimentation. The dream of the moderns, to abolish the shrines of art and finally art itself, has moved closer to an absurd reality, though for an entirely different set of reasons. One may say the current state far exceeds the dangers of the bourgeois envisioned by the moderns. But even now, when I contemplate my allegiance with the gallery, am I able to utter my sincere apology? My social code is hopelessly arrested, without evolution or the constant vigor of revisions and contemplation. Somehow I have trusted the dynamics of time, and have believed in the adventure of technology as an automatic and purifying process in itself.

72

Steina and Woody Vasulka, with half-inch CV tapedeck, outside 111 East 14th Street, Klein's Corner, New York City, 1970

Steina was born Steinunn Briem Bjarnadottir in Reykjavik, Iceland, in 1940. She studied violin and music theory, and in 1959 she received a scholarship from the Czechoslovak Ministry of Culture to attend the music conservatory in Prague. In 1964, she joined the Icelandic Symphony Orchestra.

Woody Vasulka was born Bohuslav Peter Vasulka in Brno, Czechoslovakia, in 1937. He studied metal technology and hydraulic mechanics at the School of Industrial Engineering, Brno, where he received a baccalaureate degree in 1956. Later, he attended the Academy of Performing Arts, Faculty of Film and Television, in Prague, where he directed and produced several short films.

The Vasulkas met in Prague in the early 1960s, married, and moved to New York City in 1965. There, Steina worked as a free-lance musician and Woody as a multiscreen film editor, experimenting with electronic sounds, stroboscopic lights, and, by 1969, with video. In 1971, with Andres Mannik, they founded The Kitchen, a media arts theater. The same year, Steina and Woody established the first annual video festival at The Kitchen, and they collaborated with David Bienstock on organizing *A Special Videotape Show* at the Whitney Museum.

In these early years, Steina and Woody collaborated extensively on investigations into the electronic nature of video and sound, and to produce documentaries about theater, dance, and music, particularly on the New York underground scene.

In 1974, the Vasulkas moved to Buffalo, where they joined the faculty of the Center for Media Study at the State University of New York. At this point, their interests diverged: Woody turned his attention to the Rutt/Etra Scan Processor, while Steina experimented with the camera as an autonomous imaging instrument in work that would later become the "Machine Vision" series. In 1976, working first with Don MacArthur and

then with Jeffrey Schier, Woody began to build the Digital Image Articulator. This device introduced him to the principles of digital imaging.

Since 1980, the Vasulkas have lived and worked in Santa Fe, New Mexico, where Steina has continued her work in video, media performance, and video installation, and Woody has continued to produce work in video, three-dimensional computer graphics, and media constructions. In 1992, the Vasulkas organized *Eigenwelt der Apparate-Welt: Pioneers of Electronic Art,* an exhibition of early electronic tools at Ars Electronica, in Linz, Austria, which was accompanied by an interactive laserdisc catalogue.

The Vasulkas have been artists-in-residence at the National Center for Experiments in Television, at KQED in San Francisco, and at WNET/Thirteen in New York. Individually and collectively, they have received funding from the New York State Council on the Arts, Creative Artists Public Service, the National Endowment for the Arts, the Corporation for Public Broad-casting, the Guggenheim Foundation, and the New Mexico Arts Division. Both received the American Film Institute Maya Deren Award in 1992 and the Siemens Media Art Prize in 1995. In 1988, Steina was an artist-in-residence in Tokyo on a U.S./Japan Friendship Commission grant. In 1993, Woody received a Soros Foundation fellowship to lecture and present work throughout Eastern Europe.

Steina has taught at the Academy for Applied Arts, Vienna, Austria, the Institute for New Media at the Staedelschule, Frankfurt, Germany, and the College of Arts and Crafts, Reykjavik, Iceland. Since 1993, Woody has been a visiting professor at the Faculty of Art, Polytechnic Institute, Brno, Czechoslovakia.

Biographies

73

1

Steina and Woody Vasulka

MATRIX 1970–72

multimonitor video and sound installation
black and white, sound
12 video monitors, videodisc, videodisc player

Courtesy of the artists

2

Steina and Woody Vasulka

MATRIX 1970–72

multimonitor video and sound installation
black and white, sound
16 video monitors, armature, videodisc,
 videodisc player

Courtesy of the artists

3

Steina

ALLVISION 1976

closed-circuit video installation
black and white, silent
2 video cameras, 4 video monitors, mirrored
 sphere, turntable assembly
This work was engineered by Woody Vasulka.

Courtesy of the artists

4

Steina

THE WEST 1983

2-channel multimonitor video and 4-channel
 sound installation
30 minutes, color, sound
22 video monitors, 2 videotapes, 2 videotape decks,
 synchronizer
This work was produced using a soft-keyer designed
 by George Brown. The sound was composed by
 Woody Vasulka.

San Francisco Museum of Modern Art
Accessions Committee Fund: Mimi and Peter Haas, Susan and
 Robert Green, Mr. and Mrs. Brooks Walker, Jr., and
 Thomas Wiesel

5

Woody Vasulka

THEATER OF HYBRID AUTOMATA 1990

internally interactive video/computer/sound
 installation
color, sound
tubular frame, 5 targets, computer, videodisc,
 videodisc player, video projector, projection screen,
 video camera, robotic camera head, speech box,
 audio sampler, video mixer, 6 audio speakers,
 lighting grid
This work incorporates the Lightning, a musical
 instrument designed by Don Buchla, and is operated
 with software by Russ Gritzo.

Courtesy of the artist

6

Steina

BOREALIS 1993

2-channel video and 4-channel sound installation
10 minutes, color, sound
4 translucent screens, 2 video projectors, 2 videodiscs,
 2 videodisc players, 2 mirror beam-splitters,
 synchronizer, 2 audio amplifiers, 4 audio speakers,
 2 projector tables with mirror holders

Courtesy of the artist

7

Woody Vasulka

THE BROTHERHOOD 1994–96

interactive computer-driven opto/electro/mechanical
 constructions

Table III 1994
Aluminum table, 5 screens, computer, videodisc,
 videodisc player, video projector, slide projector,
 pneumatic control system, optical beam-splitter,
 2 custom lights, midi box, audio sampler,
 microphone and drum module, stereo amplifier,
 2 audio speakers
This work is operated with software by Russ Gritzo and
 was produced with the assistance of Bruce Hamilton.

Courtesy of the artist

8

Woody Vasulka

THE BROTHERHOOD 1994–96

interactive computer-driven opto/electro/mechanical
 constructions

Table I 1996
Illuminated plotting table, computer, video camera,
 stepper motors, dynamic projection/screen
 positioner, environment sensors
This work was in progress at the time of publication.

Works in the Exhibition